Grace Lau: A RETROSPECTIVE

adults in wonderland

with an introduction by Amanda Hopkinson

ISBN 1-85242-552-0
Library of Congress Catalog Card Number: 96–071370

A complete catalogue record for this book can be obtained from the British Library on request

The right of Grace Lau to be identified as the author of this work has been asserted by her in accordance with the Copyright, Designs and Patents Act 1988

This edition first published in 1997 by Serpent's Tail, 4 Blackstock Mews, London N4 and 180 Varick Street, New York, NY 10014

Designed by Spark Design, London

Printed in Great Britain by Butler & Tanner Ltd., Somerset

CONTENTS

Acknowledgements

I am very grateful to the following friends and colleagues for offering their invaluable support and advice:

Nicholas Bodington, Mick Cooper, Felicity Edholm, Rosie Gunn, Zoe Schramm-Evans, Tim Woodward.

Special warm thanks are due to all my photographic subjects for contributing their vigorous imagination in the making of my images. Participants of the Exposures workshop all deserve thanks for supporting our exploratory classes and helping to make them successful.

My thanks to my editor, Amanda Hopkinson, my exhibition curator, Shirley Read, and my designer Angela Spark, who have been enormously helpful in the presentation of this book.

Grace Lau

Introduction

"Art, including photography weaves into language
the complex relations of a subject caught between 'nature' and 'culture',
between the immemorial ideological and scientific tradition,
henceforth available, and the present, between desire and the law,
the body, language, and 'metalanguage'."

Julia Kristeva *Desire in Language*

Mahomet's son-in-law, Ali, described it thus: *"The Lord awarded passion ten parts. Nine of these he gave to the woman and only one to the man."* If it is believed that women are inherently desirous, then the interminable romances on the theme of incarcerated maidens and sleeping beauties, even immured wives and veiled matrons, are concerned less with the protection of women from male depredations than with the dangers of women's desires unleashed.

But what is it that women desire? In 1988, when working on Spectrum, the first women's photography festival in Britain, we devised numerous categories for open submission. While there was no problem of abundance under the headings of Work – or even Play – there was nothing submitted under Erotica. Finally, after searching and eliciting, a certain amount of work was forthcoming. It was all, without exception, lesbian erotica, photographically of high quality.

Was it begging a question or blazing a trail? Or were women, as has been often claimed, simply uninterested in visual sex? Within post-feminist political debate, it was posited that women had so little cause to find inspiration in a male-determined heterosexuality that it evoked no apparent visual erotica. At least not in British photography at that time and at least not involving male subjects. The one explanation on offer was the politically correct response that power relations between men and women rendered heterosexual intercourse necessarily oppressive to the latter, so leaving little scope for celebratory aesthetics. It has only been during the last decade that change has occurred, and eroticism has entered the frame as imaged by women. A trail blazed by such photographers as Tessa Boffin, Della Grace and Jean Fraser (and projects such as the provocative Lesbian Looks) developed a radical interest in exploring sexuality through photography. By putting lesbian photography on

the map, the wider visual exploration of erotica for and by women became a real eventuality. Grace Lau's pioneering work for *Adults in Wonderland* has absorbed some of that earlier impetus.

At the time when she did, the question resolved from being "why no women's heterosexual erotica?" into "when would we see women's heterosexual erotica?" As with every major new social movement, there is a time-lag before it permeates the surrounding culture. No revolution instantaneously spawns new art, and the women's movement was genuinely revolutionizing many women's lives.

Women's initial hesitation to point the camera back at the men who had, for over a century, been using it as a tool to objectify and isolate the female nude, was partly based on perceived power-relations between men and women. Amid discussions within the women's movement around sex as power, there emerged an assertion of lesbianism as a political choice, a means of escaping relationships as decided and controlled by men and leaving women either disempowered or abused. It remained the case that it was lesbian separatists, wanting as little as possible to do with men, who set the pace. To point the camera at the intricate intimacies of what takes place between women and men at such an intimate level seemed to be taking an enormous risk, not least a risk of ridicule.

The fact that hundreds of amateur camera clubs across the country specialize in offering the male voyeur a forum for his crudest fantasies failed to counter a fear of further masculine scorn. It became an issue of creating a safe space, freed from *a priori* criticism and self-censorship, in which to explore alternative ways of looking. The critical difference between this nascent exploration would be around making rather than taking pictures, least of all in the rapacious manner conforming to a camera club format.

An important interim change occurred with a turn in focus of a camera lens, now less often pointing outwards and more often directed back at the photographer. Just as the growth of "women's writing" in the 1970s unleashed a flood of publications written from personal experience, so "women's photography" has come closer and closer to home. Contrary to what one might assume, it seems to take more confidence to direct one's gaze towards oneself than to look outwards. Just as, in an extension of the metaphor that equates making photographs with shooting people, it can take more courage to point a gun at your own head than at another's.

Many women photographers began to interpret the phrase "working with your own body" through self-portraiture. Arguably, it has become the most popular subject for women students to select. It then follows naturally from stripping oneself bare and studying one's own nudity to exploring the inter-relationship of that body, that sexuality, with another or with others. Jo Spence pioneered a whole discipline of "photo-therapy" working from her self-image, while Cindy Sherman uses self-portraiture to subvert political and publicity messages. Such a shift in praxis logically involves moving from the use of photography as a neutral medium to acknowledging the impact of the

photographer's individual subjectivity.

And it has the great advantage of reversing the gaze. Ever since John Berger's pioneering *Ways of Seeing* in 1972, many tomes have been written concerning the historical depiction of women as passive objects of male delectation. Women looking at themselves as defined by their gender – not as the incidental subjects of photojournalism and reportage, nor as "clothes horses" for the fashion world, still less as pin-ups for men (the history of women photographers in the latter fields has yet to be written) – is but a step on the way to an exploration of gender itself. (And to see Grace Lau's images is to encounter at least three genders.) To see how far we have come in analysing our perceptions we have only to contrast a statement from *Ways of Seeing*:

"The photographer's way of seeing is reflected in his way of seeing...No other kind of relic or text from the past can offer such a direct testimony about the world which surrounded other people at other times...To say this is not to deny the expressive or imaginative quality of art, treating it as mere documentary evidence; the more imaginative the work, the more profoundly it allows us to share the artist's experience of the visible".[1]
with the statement made twenty-two years on by Linda Williams in the essay entitled *What Do I See, What Do I Want?* where she analyses the quantity of female photography of male penises thus:

"Perhaps the reason for all this rather friendly curiosity lies not in the supposed lack-in-being for which the phallus serves as substitute in Lacanian theory but in the much more mundane fact that these highly various mounds of flesh constitute a very new subject area for women photographers. There is a process of discovery here and just a little fascination with an object that, in so many other places, has, for women observers at least, been the last taboo."[2]

The shift from 'documentary evidence', while importantly recognizing the photographer's presence in selecting and presenting it, could hardly be more clearly contrasted with 'a process of discovery...[with] the last taboo'. While much of *What She Wants: Women Artists Look at Men* indeed affords a copious quantity of male genitalia, Grace Lau engages with more subtle taboos. As a consequence of the pioneering work done in returning the male gaze, with or without the subject's reciprocity, the trajectory of her work has moved on from simply documenting the male nude to exploring sexual fantasies around pain and pleasure, and the delights and anxieties of gender-bending.

The first images in *Adults in Wonderland* involve bringing her subjects off the streets and back into the studio. Grace Lau began working with male dancers in the 1980s, following their bodies' structures as well as their movements. These early portraits have a lyrical, experimental quality that ruptures conventions in terms of lighting and imaging, as well as in forcing a break with her established approach as a documentarist. Deliberately excluding either a focus on genitalia or on the sexual arousal and activity of so-called pornography, she used the human subject for her own arena of interpretation and experimentation.

With an extensive experience of documentary

photographic practice and of activism in the women's movement, Grace Lau determined not to be drawn into the whole pornographic/erotic dilemma. Instead she took sexual attraction, often pursued to its bizarre limits, yet still an under-researched and under-recorded sphere as her starting point. Having jettisoned the security accorded by a tradition which afforded the photographer a certain degree of neutrality, she reversed the dictum which allowed the photographer to function as an extension of the camera. In so doing she was forced to confront her own subjectivity not only as an artist but as a person. This mirrored the dichotomy of what she later describes as her role as both participant (heightening the experiences of those whom she photographs) and artist (working according to her own perceptions).

To this she brought fierce loyalties of her own. Born and raised within a deeply conventional Chinese background with its own stern, and at times repressive, "traditional family values", she felt unable to show her parents her ground-breaking work. In the process of liberation from those values she became a strong partisan of the women's liberation movement. What the personal choices proved was her capacity to keep reinventing herself, always starting from looking anew and taking further risks, pushing out the limits while simultaneously analysing her motives and progress, underpinning the visual experiments with an ideology.

Her academically curious approach coincided with a media interest in anything deemed "hot" or "sexy", whether or not it had in fact anything to do with sex. While magazines for the delectation of "perverts" – a

name reclaimed from the gutter press and used with pride – infuriated the pro-censorship lobby, Grace was looking to apply documentary and portraiture techniques to subjects that had previously only been photographed to stimulate. Stimulate men and/or "pervs", of course.

The Times ran her colour shots of a Rubber Ball, supposedly inundated by art students with a fetish for dressing up, while her workshops at Exposures attracted coverage in the columns of the broadsheets.

Commissioned by a weekly photography magazine to attend a workshop of women photographing a male model, I was called up afterwards by the editor. Not, as I initially assumed, to discuss my copy. Instead he wanted to discuss my supplying suitable workshop photos to accompany the article. Not " suitable" in policy terms – that was straight-forward, magazine house style prohibiting any depictions "of a sexual nature". And it took only moments to assure him that there were ample sepia shots of the guy's ear and elbow. No, what was agitating the editor was his desire to see some of those pictures that were useless for publication purposes: in particular those revealing the precise dimensions of the model's penis and its state of arousal.

Back to the predictably physical parameters of male desire? Or to yet another symptom of masculine insecurity? Either way, the focus was again being hijacked from a consideration of the women photographers' gaze and the possibilities of their desire, and returned to a male discourse. And again one man's closeted desire to privately examine what he called "sexy

pictures" which had no purpose for publication, reflected an unwillingness to take seriously that there could be another genuine and pioneering way of seeing in the (woman) photographer's eye.

Outside of explicitly gay journals there was little imagery of male arousal that might arouse women. Women's desire, and its susceptibility to visual arousal, is still open to question. The failure of erotic magazines for women, such as *Ludus* and *Playgirl* – with their predominantly gay readership – is awarded exploration and explanation in Grace's own text. As is the recent phenomenon of "hen parties" to visit shows of male strippers like the Dream Boys or the Chippendales. Neither has succeeded in matching female fantasies. The anatomical explicitness of *Playgirl* deprived it of necessary intimacy and mystery, while the male strippers are treated by the majority of their mainly aging audiences as the opportunity for a good shared laugh rather than an erotic experience.

Does all this further contribute to minimizing the role of women's supposed penis envy? It was Freud who, after all, basing his researches on a restricted clientele of wealthy female patients in Vienna between the wars, coined the term "scopophilia" to describe the delights of seeing. If the phallus or obelisk can be taken as a potent symbol of towering power, precisely because latterday psychologists are loath to equate an erect penis with the undisputed object of desire by either gender, then it may be the signifier – power – and not the sign – penis – that women desire. Photography, by dint of its necessary relationship to the "real" world, is perhaps the worst

medium for eliciting female arousal. Simply returning the male gaze and objectifying men as the agents of erotic contemplation for women seem attempts doomed to failure: they are either ignored, discarded, or seen as amusing.

Grace Lau's portraits are not pornographic in that they are not designed as masturbatory aids. Nor do they deal artistically in the closer intimacies that, supposedly, are the space that women want to sexually inhabit, as opposed to the distance created by objectivization. On the contrary, her currency is fantasy. Not the world of fantasy as described by the interviewees of Shere Hite or Nancy Friday, so many of whom seem devoted to black-clad rapists violating them at dead of night. Instead Grace Lau's subjects actively determine their own gratification – sexually through performances of what she terms the "masquerade" and financially, in terms of how much dominatrices can earn for their services. Thus these particular sexual fantasies occur, as in Carroll's Alice books, "contrariwise", the women wielding the power along with the whip.

The achievement of the fantasy depends to a large extent on the acting-out of a whole spectrum of desires. In going "through the looking-glass" nothing is prohibited, therefore everything is permitted, sampled, appreciated. The looking-glass itself has a part to play, serving as a stimulus even to the most solitary narcissist. The interplay between the lens and the mirror, with Grace herself not infrequently appearing in reflection, is at the crux of the exhibitionists' desire to present themselves. And it is important to recall that there is

nothing whatever furtive in Grace's own approach: she is always canvassed and frequently commissioned to take the pictures she does. Why else do her subjects go through the performance, with all the preparation and dressing-up, if not to take and keep a visual record? And the more isolated the protagonists – those comfortable, everyday middle-class couples in the Shires and the Home Counties – the more wicked their activities appear in contrast with their daily lives and the keener they are on the camera's witness.

Much of the visual record produced seems very "safe": consensual games played between adults, usually a couple and often married. However, Grace herself is not the neutral witness her camera represents but an impassioned advocate of the liberating and celebratory aspects of such rituals. Even the fetishes can be seen as mutually complementary: the men in oversized scarlet stilettoes are not merely ridiculous, eg Lynford Christie at the starting gun for his Nike advert. The shoe itself boasts the twin aspects of spiky heel and tight enclosure. It reappears again and again, on men and women, and as a background image, often reflected in a wall mirror. Or, in the words of Michèle Roberts's poem *Masochism 1*, reversing the masochism back to the woman:

> the arch of her foot
> dark, like a grey breath
> cherry suede bridge, shoe
> binding flesh in
> red-patent, snappy bright bars
> tender tickly constraint

> he picks fruit, she feels
> delicious
> flurries of pain[3]

However, there a darker side persists in making its presence felt, beyond the glass. Some things are outlawed even in "consensual" practice that impinge on private fantasy. Or, even, in the space occupied by Alice in Lewis Carroll's visualization:

> Still she haunts me phantomwise
> Alice moving under skies
> Never seen by waking eyes.[4]

Ruminations which point to the subliminal importance of the "real" Alice Liddell, with whom Carroll was obsessed. The duality of the actual child, to whom he told fantastical tales, and the fantastical child, who existed and excited him in his dreams, echo the duality that is photography – at once the record of something external and the expression of an inner perception. Reflections which remind us that the author of *Alice In Wonderland* and *Alice Through the Looking-Glass* was after all no mean amateur photographer. His favourite topic was the same little girls he liked to amuse with his fairy stories. Only instead of dressing them up as for conventional studio portraits – with smocking and sashes, Alice bands and white slippers (like little girls, in short) – he preferred to suggestively pose them on a loveseat, clad only in petticoats, fishnet stockings and long lacy gloves. The link between the adult in the eye of the beholder and the child seen by the camera exactly

proportions that between fantasy and photography.

It would be hard to conceive of such images as taken by a woman. Dodgson's fellow high Victorian women photographers, Lady Hawarden and Julia Margaret Cameron, certainly photographed children, but saw them as genuinely innocent rather than as manipulatively knowing. The one contemporary female photographer arguably working in the genre, the North American Sally Mann (who uses only her own children as models), has long been in the eye of a storm disputing her "right" to do so. It will be interesting to learn how those children view their exploitation by the camera when they become adults and re-view their nude portraits with the hindsight of maturity.

The spectrum of photography is as wide as that of gender: women's photography can span as much as women's desire. Lewis Carroll's use of young girls (he is famous for announcing that he liked all children except boys) is on the far side of the cutting edge of consensual photographic practice, where the photographer's subjectivity (or desires) entirely over-rules that of his subjects. The expression "wonderland" could as well have been coined by Carroll, for the particular characteristic it carries. This links it ineluctably to Alice and so to childhood, a particular view of childhood. In the present day, its closest equivalent might be the children's playground constructed by pop star Michael Jackson and which he called Neverland. Grace Lau's non-documentary work specifically excludes children, imaging instead how a Wonderland is prolonged in present-day adult

fantasies as guileless as fairy-tales without child protagonists.

What most characterizes women's work in our society is a degree of intimacy, at times intensity, and a significant lack of the detachment that makes pornography easy. To hear Grace Lau talk of her subjects is to hear curiosity, tenderness, familiarity, amusement. The fantasy world they inhabit – the balls and parties; the props and costumes; the dressing-up and toys; the false environments of castles and dungeons – are even more the stuff of hookah- or mushroom-induced hallucinations than white rabbits and talking caterpillars. Welcome to *Adults in Wonderland*.

Amanda Hopkinson

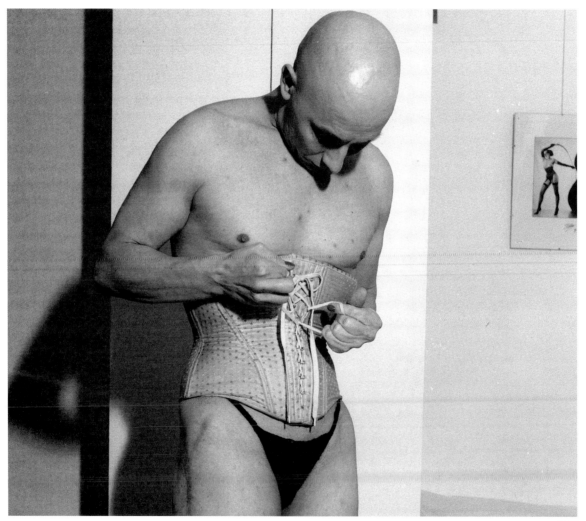

1989

14

Men Undressing –
or Dressing Up?

Picture this scene: A pretty young, perhaps naked, girl adopts a provocative pose for a studio photographer, male of course. He focuses – snap – the following image is consumed and possessed by a multitude of men.

Another typical scene: An annual amateur photography trade fair. Hordes of men laden with cameras converge towards an arena where a professional photographer holds forth about lighting techniques while his pretty young model adopts a seductive pose. To sell films, maybe? More likely to sell an erotic fantasy about possession – through the phallic camera lens. The amateur photographers zoom in – snap – the girl belongs to them.

On to a more explicit scene in the basement of a Soho bookshop specialising in 'adult material'. Shelves of magazines tightly wrapped in Cellophane with their covers offering sexy images of women in all possible positions. What an expansive choice for the men, a supermarket of flesh in different shapes, colours and ages.

Erotica for women? What is that?

That was a new concept in 1980, as I embarked on a Critical Media Studies degree course, selecting my research topic. Despite feminists' formidable work in pushing for women's rights, women artists appeared to be still restrained in the area of expressing their

sexuality. Or was it more complicated? Could it be that women's visual erotica were simply not accessible? If that was the case, clearly the distributors of magazines, journals and even gallery curators needed to adopt an enlightened attitude to break through the conventional monopoly of male-made, male-orientated and male consumers of erotic imagery, particularly in the photographic domain.

It also occurred to me that perhaps women were themselves uncomfortable and ambivalent about articulating their sexuality through art, in case their own stable relationships were adversely affected should their male partners feel threatened or diminished by their (women's) exploratory artwork.

In 1979, Michèle Roberts (*Women's Studies International Quarterly*, U.K.,) defined the photographic situation: "A male-defined cultural tradition in photography will only be shifted if more women go the other side of the lens to act as controller instead of the controlled, and contribute toward a reconstruction of positive images of women. The contribution feminist photographers can now make to their cultural identity has importance within the Women's Liberation Movement and toward the establishment in general of a woman's cultural identity."

For women to redefine themselves in anything other

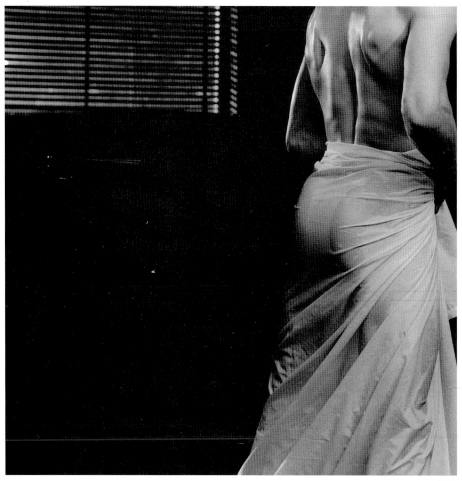

1984

than male cultural terms still involved problems of personal and social dilemma, confrontation and alienation. This posed a challenge to me. I had found my research subject. It was clearly appropriate and timely that I should use my camera to address women's lack of erotica through their own representations. Perhaps a female perspective would present an alternative view of erotica that was celebratory and reduced some of the dark guilt around the subject.

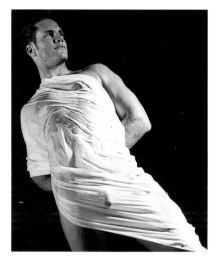

Radical feminist politics from the States were raising the consciousness of my feminist friends and colleagues, but it was also a time of ambivalence and confusion amongst feminist groups and individual women artists. Women art historians such as Linda Nochlin, Griselda Pollock, and Margaret Walters were the inspirations for our critical theories research, and the books of John Berger and Susan Sontag encouraged us to take control of our own forms of expression and desire. In spite of such powerful support, it still felt inhibiting to create photographic work that would not simply be interpreted as crude pornography – how and where could I begin?

Subsequent questions were raised: what did women want? Might they want explicit pornography? Where could I find reference material for research? The ongoing public debate about definitions of pornography and erotica intensified to further confuse the issue. To place my work in a personal context, my own cultural conditioning was a strong force and once I started to consider male nudes as photo subjects, I was sharply aware of the effects of strict upbringing in my youth. Paradoxically, my inhibition actually led to an urgent curiosity to investigate lust and libido, using photography as a medium – perhaps even as a spatial protection to start with. For the camera necessarily required a technical distance between the photographer and the subject and this distance provided a safe space for me to start to explore sex and erotica. Curiosity did not overrule a certain trepidation.

My primary concern was to address the imbalance between prolific

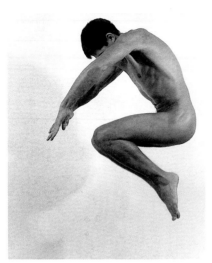

1993

topshelf material for men and the lack of equivalent images for women and I began by focussing on male nudes. Backed by my feminist convictions and the growing number of essays about women's art, I set forth to search for reference material. I looked everywhere. There was nothing for women. Plenty of bare female flesh for men, some male flesh for gay males. From local newsagents to Soho sex shops I scoured the shelves and embarrassed many raincoated gentlemen by asking them to reach up for certain magazines which were beyond my short reach. I built up a sizeable collection of pornography (much to my brother's delight) and drew some conclusions. Explicit sex and women's anatomical details seemed to fulfil most men's masturbatory needs. These single constructed images, taken by male photographers in their studios, were repetitious, unimaginative, unaesthetic and ultimately, very tedious. The variations on the same themes: women with animals, Black or Asian babes, big boob babes, over-forties femmes, 'lesbian games', seemed to me objectionable and cheap. But they sold and sold and the industry was obviously thriving on male lust.

And where were the images for women? The Soho shops were heaving with hot male customers and, very occasionally, a timid girlfriend in tow. I did see that some Ann Summers highstreet sex shops were well-attended by women, always shopping together or with their men friends, whereas the Soho shops were inevitably attended by single male customers. Later, I found out this same formula applied to striptease shows.

Male nudes were not readily available for women photographers at that time. In the beginning I had little notion of what defines erotic imagery for women, but I needed to experiment and started the hunt for hunks in my local gym. I found that the body-builders were certainly happy to pose for me, but their agenda did not match mine. They wanted to admire themselves in a photograph which would reassure them of their superb physiques. The print, like a mirror, should reflect their ideal selves, whereas my own intention was contrary and directed towards

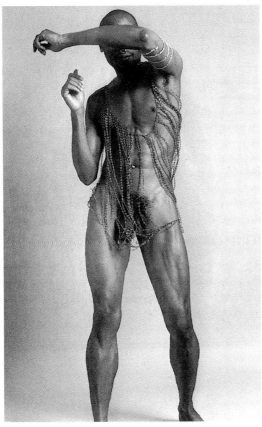

1986

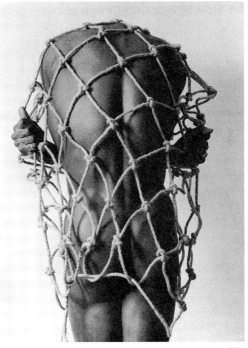

1984

making images for women. Nevertheless, it was a start and I learned to direct big beefy men for my camera. The experience was empowering.

In terms of applying photographic theory to practice, I was keen on creating picture stories in a narrative form; to transfer the tension present in a picture out of its frame and to engage with the spectator. In this, I was influenced by Roland Barthes.

"The erotic photograph does not make the sexual organs into a central object; it may very well not show them at all; it takes the spectator outside its frame, and it is there that I animate this photograph and that it animates me."

His idea was supported by my women friends and colleagues. When asked for their definition of erotica, the consensus had been towards images that allowed a space for their own participation, for their fantasy to be projected on to and absorbed within the depicted action. Also, they preferred images that implied a storyline, suggestive of a narrative, and not single explicit images that were too clearly and cheaply constructed and affected them like a full stop. Images that were, metaphorically, a comma rather than a full stop were much more powerful. Sometimes, an absence as much as a presence in the picture can animate the viewer's imagination. Subtle suggestions, not statements, were required.

So I added discreet props to enhance my body-builders' poses such as ropes and chains to suggest bondage fantasies (my own). But they were not to be distracted from their own iconography. Muscle definition was their objective, not definitions of erotica. However, their fascination with mirrors stimulated a new dimension to my work. I became fascinated by reflections and by the relationship between the camera lens, the subject and the mirror. What is reflected back to the subject? What does the photographer (me) think she is representing? The notions of voyeurism, of scopophilia, and the sense of infinite levels of displacement that could be explored through mirrors and through lens were fascinating notions. Thereafter, I was always aware of putting myself in the picture by way of

'Photography can be a mirror and reflect life as it is. But I also think it is possible to walk like Alice through the looking-glass, observe the puzzles in one's head and discover another kind of world with a camera".

Tony Ray-Jones *A Day Off, An English Journey*

20

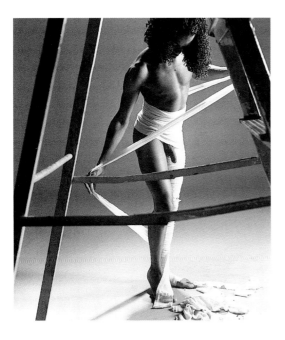

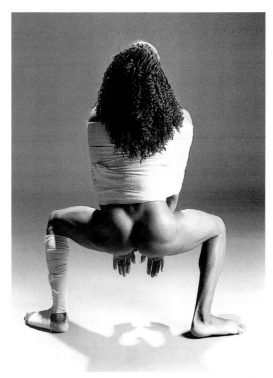

1991

a mirror. To me, that indicated a real engagement with my subject.

Male dancers were more in tune with my objectives. Many were happy to pose naked and were able to project their flexibility of body and mind in collaboration with my ideas. In my experience, Black male dancers were particularly sensitive and co-operative because they were comfortable in their bodies, and did not appear embarrassed by any homosexual or homoerotic issues. At this time I was still at the stage of constructing set-up images in my studio where I felt in control of my environment and my equipment. It was an empowering period for me, liberating in terms of creativity and in terms of personal development. Although I called myself a feminist photographer and was directed, to an extent, by feminist principles, my best work was created outside a rhetorical framework. My best images were not pre-planned but mutated during a photo-shoot in mutual collaboration with my subjects. I learned that the most effective pictures could be disturbing to, but should not repel, the viewer and that women's erotica was a dynamic concept that seemed too fluid to visualize effectively in photographic form.

During my searches for visual reference, I noticed that the photography sections in bookshops did actually stock a fair number of *How to Photograph the Nude* and the authors were invariably men, the models were predictably women. The amateur photographers' magazines and trade fairs reinforced this status quo.

My subsequent work engaged women into the erotic scenario as many women had indicated they were aroused by the sight of couples. Again, I looked for visual material as reference, but topshelf material only provided predictable pictures of couples in some explicit positions, always for the male consumer. What could I do to offer alternative perspectives to the female gaze? Could I parody the established formula? Or imitate, in a male language? I wanted to subvert and to destabilize the male gaze sufficiently to allow space for the female gaze to be engaged. It seemed a lonely pursuit in the early 1980s and my ultimate ambition was to start a magazine that addressed erotica and sexual issues for women. But such a publication did not materialize until nearly ten years later, and then it was ironically published by a huge commercial men's magazine conglomerate. Meanwhile, I experimented with couples photography in my studio. But my pictures lacked the realism and tension that was important for effective engagement with spectators, and this was because the lengthy technical precision of constructing an erotic studio scene caused a loss of spontaneity and sensuous frisson – essential ingredients for a sexy picture.

The idea of female subjects also aroused my curiosity as a natural progression from the work on male nudes and couples, and I returned to the gym to find female body-builders. The gym had been a good starting point. Dynamic Diane was my best model, and my first *Time Out* cover girl. She was fantastically well-built, confident, feminine and supportive to work with; she understood my objectives and even wore rubber in the gym for my first fetish fashion shoot. I related to Diane's power, to her sexual identity as a strong woman, and she related

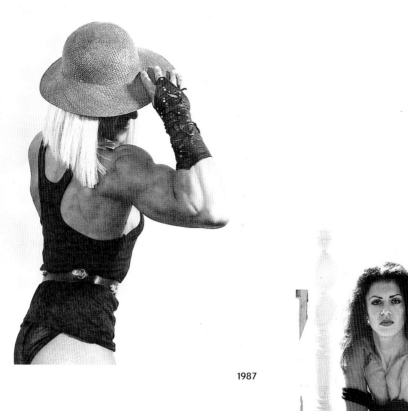

1987

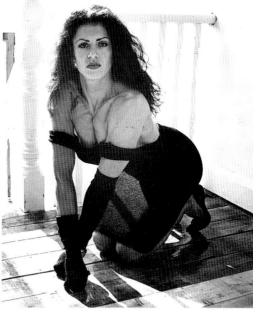

1987

23

"Postmodernist art accepts the world as an endless hall of mirrors, as a place where all we are is images, and where all we know are images"
Andy Grundberg, *Crisis of the Real*

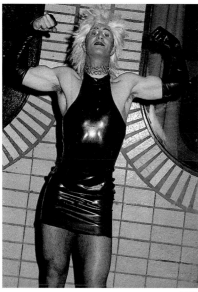

1989

to my camera as an exhibitionist: we were a creative and supportive team. Some of my most successful images played with the notion of androgyny and many people thought the *Time Out* model was actually a man.

Subsequently I discovered that many men liked my photographs because they were erotically aroused by strong beautiful women; they fantasized about being in her power, being dominated and subjugated by her. Even humiliated by her. I learned a keen lesson: to take erotic pictures for women could have a subsequent and unexpected subtext: they provide a turn-on for men. Did I want that? Had I anticipated that? It was confusing issues by subverting my original intention of producing images for women. Did that mean a consequent loss of control? And surely I was aware that certain images of sexy lesbians were arousing to many men? Yes, but what about strong powerful women? More issues to explore.

As it happened, some of my images of women were also eagerly taken up by the lesbian community, which was another unintentional – but not unwelcome – outcome. So at this stage I decided not to discriminate between the audiences for my work, that as long as it communicated to people it was fine. And I continued to shoot erotica – not just for women but from a woman's perspective – for everywhichone. Perhaps the continuous dialogue about definitions of erotica and pornography could be resolved by an all-inclusive terminology of 'postmodern porn' which became a way of describing my work whenever the question arose: "Is it erotic or pornographic?" I would answer: "It's about polymorphous perversity, or call it postmodern porn," which abruptly ended any further discussion as I had not yet myself reached any further definitions. In any case, I believe my work contained many elements of postmodernist art in deconstructing traditional concepts; making new reference points; in revealing and concealing identities, and in my role as a 'catalyst camera' to animate my subjects.

My first solo exhibition at a gallery in King's Cross, London in 1987 gained me notoriety in a big way. From the *Time Out* cover and interview, to most of the broadsheet press, to radio and TV, including European TV, it was the most successful exhibition the Submarine Gallery had held in terms of audience numbers. I even sold enough prints to cover my expenses, and I was much encouraged by the critics.

Val Williams, in the *New Statesman*, observed: *".....Lau's work does much to demarginalize pornography, and to return the picturing of eroticism to its established place within British photography. Lau proves, too, that a woman's pornography does not have to be parodying or satirical, and that there are no areas of imagination which feminists must avoid. Photography, like Lau's which portrays and supports a particular sub-culture, is important too in that it radicalizes something which is frequently consigned to the tatty fringes of commercialism. Removed from its niche of sexploitation, pornography becomes not only art but also a coherent political position."*

What intrigued me about this exhibition was the number of anonymous grey-suited businessmen emerging from King's Cross Station who visited the gallery when it opened in the morning on their way to work in the city. Their furtive behaviour revealed a guilty attitude which conflicted sharply with the celebratory flavour of my pictures. However, it was gratifying to observe such a diverse cross-section of visitors to the gallery, the gay population as well as the fetishists, as well as art and photography students. The businessmen,

I suspect, were focussing on my latest bondage and S/M fantasy images which was a gradual progression from my erotica work. To go through the mirror would later reveal complex layers of character identities played out in a bizarre and sometimes obsessive masquerade by a startlingly high proportion of the population. There are darker identities under layers of masks that would be revealed to my camera, invisible to public vision and condemned as freakish or sensationalized by the media but which, to me, have been positively enlightening. An important transitional period was about to happen through the subsequent sequence of mirrors.

A particularly intriguing aspect of 'identity dysphoria' that now drew my attention was androgyny. After my fascination with hunky body-builders, followed by a focus on lean and lithe dancers, my next direction veered towards more feminine-looking young men, with softer features and bodies. Many of these men would play with gender roles, wearing make-up and women's clothes, but with a deliberate show of masquerade, allowing their masculinity to show through. Not quite like the comedy-act drag queens whose style of mocking parody often came close to misogyny, these androgynous young men appeared to combine the essence of male and female in a single erotic body that attracted both sexes. David Bowie was a prime example for my generation, and I met most of my androgynous subjects working in the music world. They were invariably young, vain and self-absorbed – but so pretty!

Later on, my attention was drawn to transvestites who occasionally carried the role reversal act to the point of

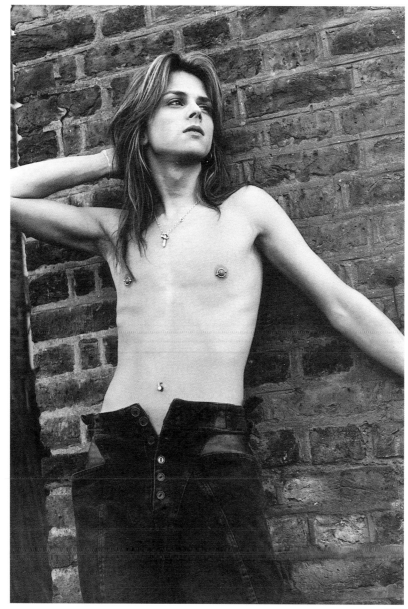

irreversible medical transformation. However, there were many men in various stages of flux and transvestism, some confused and unhappy, others contentedly balancing their duality. I advertised my photography services in the *Skin Two* magazine, and most of my clients were transvestites, or cross-dressers. There is actually a subtle difference in these labels. Cross-dressing applies to those men who are undoubtedly hetereosexual and straight, but who occasionally like to wear women's garments. Many just enjoy the clandestine thrill of taking a risk, wearing women's underwear beneath their grey suits in public situations. Some transvestites (TVs), however, have an uneasy relationship with their duality and many are gay or closet-gay. Others feel themselves to be essentially female but trapped in a male body. The next group are those TVs who actually become post-op TVs, that is trans-sexuals: in the 1960s the most famous was April Ashley.

I became much more fascinated by men dressing up than undressing and my photography work took on a new dimension. I learned some of their language, their fantasies and desires and their tricks of disguise. Male nudes for women had become mainstream by the mid-1980s and technically perfected by commercial photographers in the States such as Bruce Weber and Herb Ritts. Such competition was beyond my resources: there was no Muscle Beach in London, no equivalent to the beefy Californian scene. My photography took on another new direction. How could I visually represent dual identities in a positive and informative manner?

One of my best photo-stories took place in Amsterdam. A cross-dresser friend of mine invited me to document his transformation for a fetish party and warned me that he needed a whole day to prepare him-to-herself. We started in the late morning, when he meticulously painted his nails bright red. We selected a few party dresses for him to try on, a few wigs and various corsets and stockings. For the ritual of preparation is as important as the actual party-event itself, the fantasy begins as soon as the nail-varnish bottle is produced. His make-up took over four hours in front of three mirrors with an impressive range of cosmetics. He was a handsome man who, over the course of ten hours, became a sexy and beautiful female, while my camera became an intimate and close confidante.

I felt privileged to be present, although far too exhausted to accompany him to the party, whereas he became more energized as his feminine persona took over!

Finally, at 9.00pm, he teetered off on his stiletto heels to enjoy himself through the night, with his girlfriend who only took an hour over her preparations. He was still in his dress and make-up the next morning when I came to visit, having just returned home.

A few questions remain to be asked about the sex magazines for women that proliferated in the early 1990's. Following a more enlightened attitude towards visual sex material for women, it was apparently timely and commercially viable to publish bold new magazines. Titles such as *For Women, Ludus, Women On Top* all

"What do I see? I see pornography and eroticism, I see intimacy and distance, I see penises and phalluses. What do I want? Most of all, I want the chance to keep exercising my greedy eyes, the chance to keep looking."
Linda Williams *What She Wants*

emerged within one year amidst much publicity. I and my colleagues (by now, many other women photographers had discovered the male nude) were in demand for the year these magazines lasted. One reason they failed is possibly because the distributors were mainly male monopolies who felt threatened by the positive surge of female sexuality being expressed which was beyond their comprehension, and so declined to place these magazines in the mainstream shops except on a few top shelves. Women generally do not want to engage with topshelf material, which relates to hardcore pornography for men.

There is another significant point: all these women's sex magazines were published, and therefore controlled, by the big conglomerates which publish men's sex magazines. Relatively few women photographers and writers were really involved as contributors and the male editors rarely bothered to check what women really desired. Consequently, much of the published material merely reflected what men thought women wanted. Many women did express a wish to see passion naturally indicated by an erect penis, but that was deemed to be obscene (and liable to corrupt!) under the terms of our dated obscenity laws, so we were forbidden to view anything other than absurd parodies of male pin-ups, or saccharine and romantic Mills & Boon clichés.

Before the magazines folded, however, I enjoyed a brief television appearance in 'Rude Women' for Channel Four, when they filmed one of my shoots for the *Ludus* magazine. Using rolls of kitchen clingfilm, I wrapped up a hunky male nude and photographed him in light bondage play. This little footage became notorious and clingfilm became a popular requisite for nude rude shoots, and I suspect it developed certain other uses outside the kitchen.

Over the past ten years I have noticed that the issue of sexuality and gender has been pursued by a growing number of women students in the visual arts. My own earlier pictures now appear somewhat dated and restrained compared to some of the bold new imagery. Women are

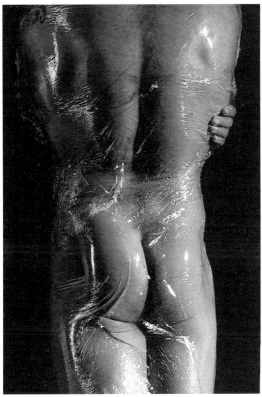

1992

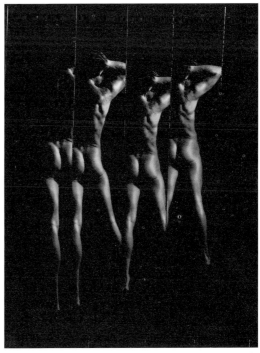

1991

"Oh, Kitty! how nice it would be if we could only get through into Looking-glass House! I'm sure it's got, oh! such beautiful things in it! Let's pretend there's a way of getting through into it, somehow, Kitty."

Lewis Carroll *Through the Looking-Glass*

increasingly taking control over defining representations of the erotic through the lens, and empowering themselves by looking back instead of being looked at. Furthermore, they are even permitting themselves to be looked at, and deliberately encouraging this, under their own active direction instead of submitting in the customary passive manner. And how encouraging it is to observe that these younger women now have so much more visual reference material to support their work than I had when starting out. The bookshelves are now displaying vastly more male nudes, although it is still noticeable that the authors are male photographers and the imagery is addressed to an expanding gay audience. The presentation of female sexuality remains static within the porn genre or for the lesbian market. Cultural theory and feminist art history have labelled the female form to be a politically thorny subject to represent visually for heterosexuals.

Ultimately, the controlling factor in marketing erotica for men or women is financial and this relates to market demand. It appears that women's demands or concerns are focussed more significantly on their practical domestic needs, sometimes on their professions, and their eroticism is sufficiently addressed in the popular monthly menu-beauty-health-care journals. So a magazine solely devoted to sexual issues might seem superfluous and even trivial, not to mention the purchasers' problem of feeling anxiety or even guilty over desiring and buying erotic imagery. Perhaps until some financial control of the big magazine conglomerates is assumed by women who are committed to investigating what women want, and until women look imaginatively beyond their popular monthlies to demand more choice of visual material, a persistent absence of sex magazines for women will continue. If Norway can produce a magazine like *Cupido* successfully for both men and women, why can't we? Why is there a sharp distinction between imagery for men and for women? Surely there is an amorphous imagery that addresses and engages both? I feel there is still much to explore and to learn.

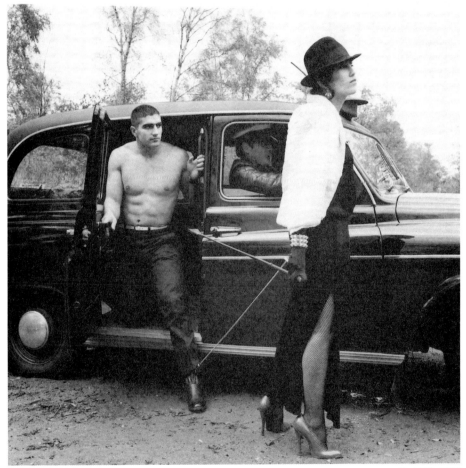

Taxi Ride 1987

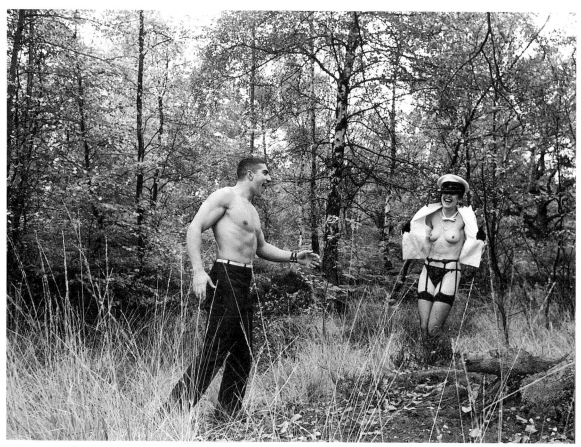

1987

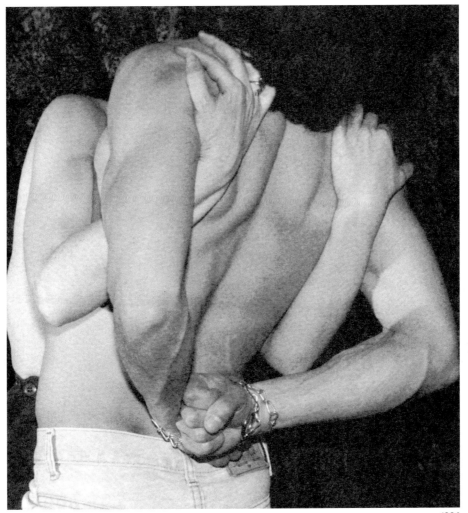

1986

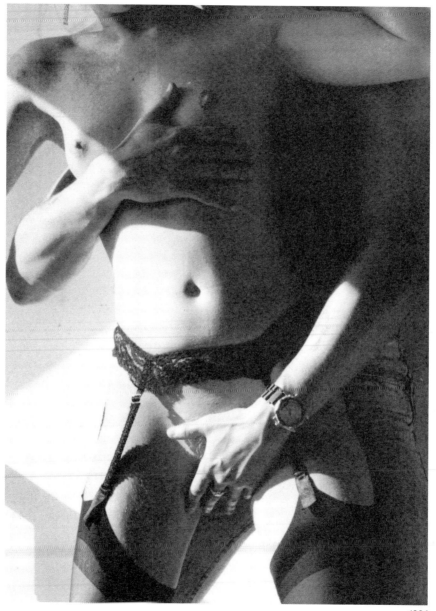

1986

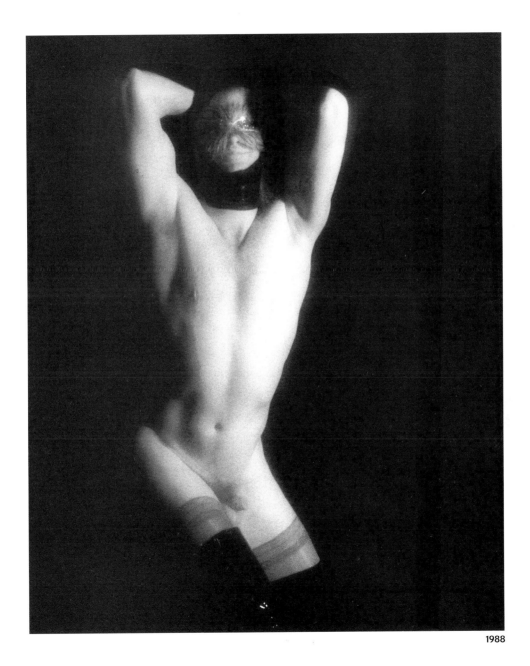

1988

35

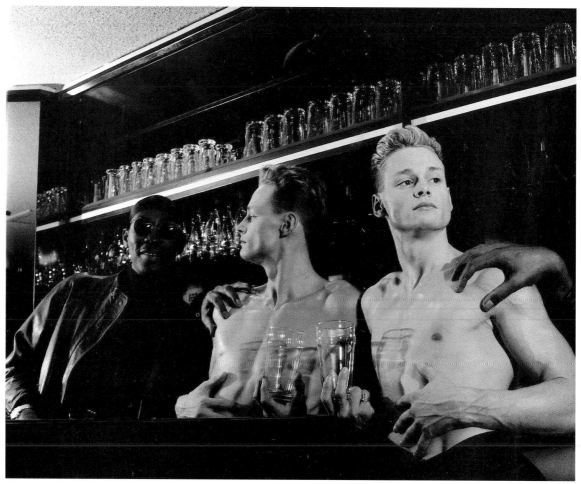

1986

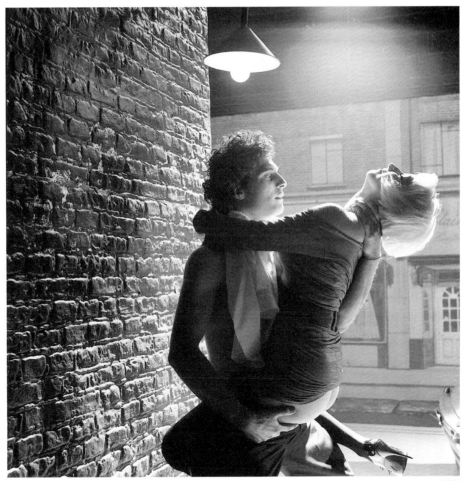

1991

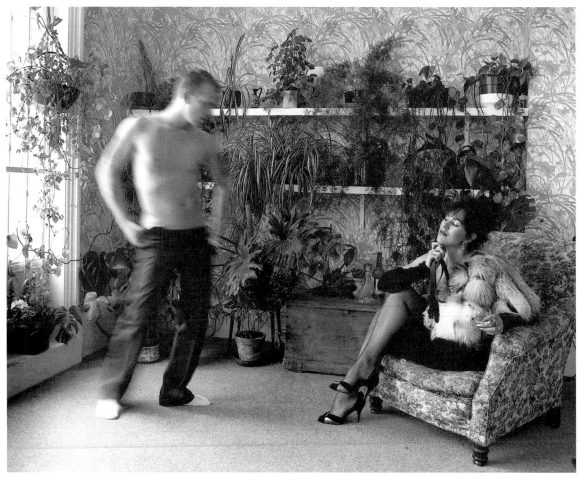

1984

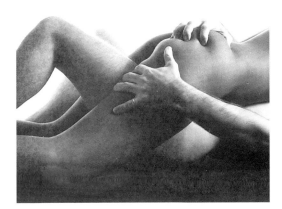

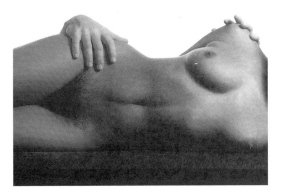

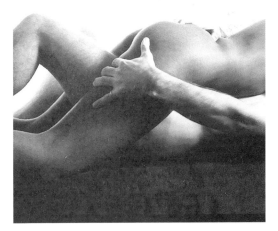

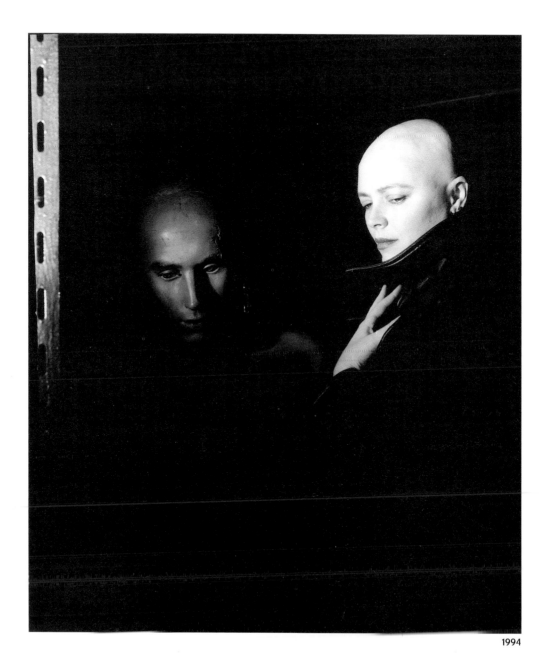

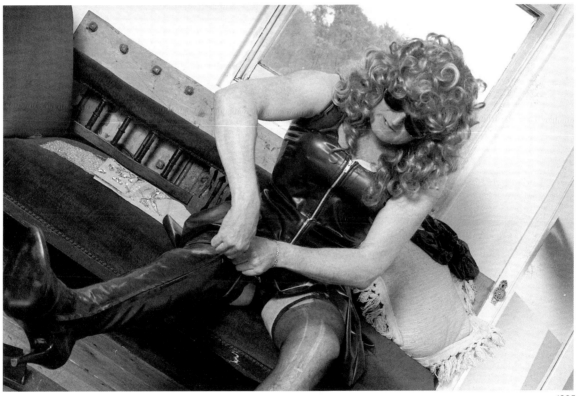

1995

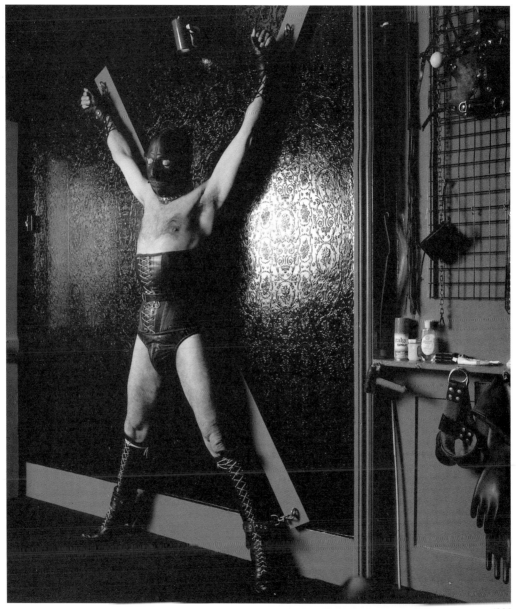

Dungeons
and Disneyland

Having helped to pioneer the concept of photo-male nudes for female viewers in the early 1980s, and discovering in the process that women really preferred to have a story-line around their male nudes to engage with, I decided to broaden my visual horizons, hitherto limited to my studio and domestic areas. Subsequently I found a sub-culture scene so bizarre and fantastical at first that it was several months before my initial anxieties disappeared sufficiently to allow me a pleasurable involvement.

In this next section, I will take the reader through the looking-glass to a world of make-believe, of masquerade and role reversals, of fetish and fantasies, dungeons and corporal punishment, body art and pure theatre. Sado-masochism can sound scary and violent if you read the tabloids. My own observations and experience revealed the reverse. Apart from one encounter with a gay serial killer (now in prison), most of the 'scene' people have been genuinely caring, friendly and intelligent. There are always exceptions in every sphere of society who are unstable, but generally, scene people could be your normal neighbour who occasionally indulges in some complex grown-up games which involve dressing-up with an erotic element. Sex is not always the crucial issue. It is frequently the oblique motivation but not necessarily the end result. Trust is of utmost importance,

especially when engaging in bondage or slave and mistress games. Submissive and dominant roles are referred to as subs and doms. Corporal punishment is CP, and BD means bondage and domination. The participants call themselves 'pervs' and the tabloids call them 'perverts'.

The pervs that I know are generally very imaginative and an integral part of the scene is the ritual of preparation. Sometimes, this takes weeks of anticipation and intense planning. The secrecy and illicitness is often part of the thrill; some people are life partners together but a great majority are lone men whose wives are unaware of their alter egos and theirs can be a sad and lonely pursuit. These men often hold high-powered and responsible positions in their professions and consequently feel the need for abandon and the relief of engaging in the safe non-judgemental environment of the scene. The scene is the mad-hatter's teaparty from *Alice In Wonderland* where all are equally insane. I have noticed that there are no social discriminations against class, race, gender or age. All are welcome and made to feel safe. The only entry requirement is ATTITUDE.

In the early 1980s, a small discreet club called Maitresse opened its doors to a select membership in Soho, London. A friend of mine, a banker, invited me to see something strange relating to my research on visual

erotica that would 'broaden my horizons'. My recent experimentations with studio-constructed images and friends-models-doing-me-a-favour lacked sufficient power. There was a missing dimension in the very form of my photography. I needed real-life documentary pictures; a real-life context for my pictures and the narrative to tell a story. The single studio images were moments in isolation whereas the tension inherent in a picture-storyline would be far more effective in stimulating attention and feedback. I decided to accept the invitation, and prepared myself.

What first struck me in the dim underground club was the vision of pure theatrical presentation in fantastical costumes. Silently slinking through the dense, heavily-expectant atmosphere, or suggestively swaying to the metal music beat, there moved 'aliens' from the future adorned in studded leather catsuits and harnesses; clinging rubber corsets; thigh boots with 5-inch stiletto heels; shiny PVC, chainmail, masks and hoods; and plenty, plenty of bare unashamed flesh. Flaunting flesh that sweated and wobbled and that bore red raw signs of abuse, abuse by whip or cane or one of the many punishment-toys that were being conspicuously wielded, mainly by women.

The women were majestic and magnificent. Exuding an aura of power and sex, they were the first dominatrices I had met. I was fascinated, I was hooked, my allegiance to strong women shifted from the relatively safe area of the gym to a new area of steely punishment. To dungeons. The dominatrices' apparent power over the grovelling men who competed to

literally lick their stiletto boots was mesmerizing, this was feminism taken to its ultimate. Or was it? Much further on, beyond the looking-glass, I needed to ask some pertinent questions about the paradoxical power relationship between the maitresse and her slave; about this form of consensual and theatrical sadomasochism and how far the participants needed to push their pain thresholds. Also, about the censorship issues and media attention focussed on this form of 'perversion'. But, in the beginning, everything was contrariwise and magical through the looking-glass. 'Curiouser and curiouser,' a new dimension of rich visual resources opened up for me.

In the beginning, my urge to photograph such a dynamic scene was restrained by my reservations. As a relative newcomer, I thought the scene people might be hostile to an intruder with a camera observing from the sidelines like a voyeur. And where could I display these images? Were they exhibition material? Certainly I did not intend them for press publication as the press would most likely distort and sensationalize the subject out of all proportion. I had many unanswered questions as I started out to explore these new boundaries.

During my many subsequent visits to the Maitresse club, I gained the friendship and confidence of the pervs who were eager to exhibit their fetishes and fantasies for my camera. Many spontaneous acts were performed in mistress and slave roles when the slave was deliberately disobedient, or made a mistake and evoked her displeasure, causing her to use her cane, whip, or crop on his prone body.

The silent but potent relationship between the two was

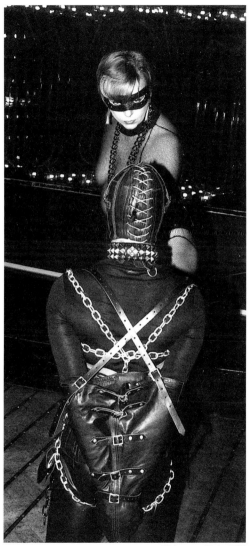

Maitresse Club 1983

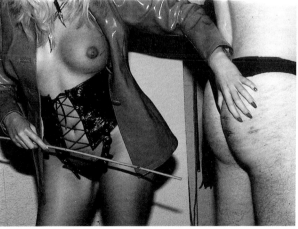

1983

heavy with erotic frissons. I felt compelled to carry on photographing, and from the fringe of the activity I began to move in closer and closer. At times, I felt as if I was almost part of the act and my role was somehow also written into the script. The scene was infectious. Eventually, I even felt drawn to join in some of the action and adopted the mistress masquerade. But I felt more comfortable with my camera than a cane, and the power of wielding my camera to stimulate such uninhibited action was my own power-trip: my camera was my cane.

Subsequently I was invited to photograph some private SM parties, many taking place in suburban London where spare bedrooms were converted into soundproof, lightproof 'playrooms for pervs'. Some parents used their loft so that their young children could not access their hidden pleasure room; others were very imaginative about conversions where hooks and chains were hidden behind pictures and curtains, where racks and St. Andrew's crosses could be pulled out of cupboards, and inconspicuous chests contained mediaeval torture toys. Many a normal suburban semi would contain the most elaborately-constructed fantasy space where reality could be suspended in an adult wonderland.

At times, I feel that all the world outside is indeed a stage and that the scene I am photographing is so intense and vividly real, the rest fades into insignificance. At other times, I feel quite detached from the staged story before me, and desire a release into the 'real world' instead of feeling secure in my own identity,

I sometimes experience a sense of fragmentation the more photographs I take, as if I am being splintered and absorbed into so many masquerades and roles. My energy becomes totally engaged in the photography with my camera acting as a catalyst to animate the action, and my self becoming more destabilized as the acts become more demanding. But the direction of my new work was a compelling force and my curiosity was still unfulfilled so I followed my camera deeper into the looking-glass, pushing at further boundaries

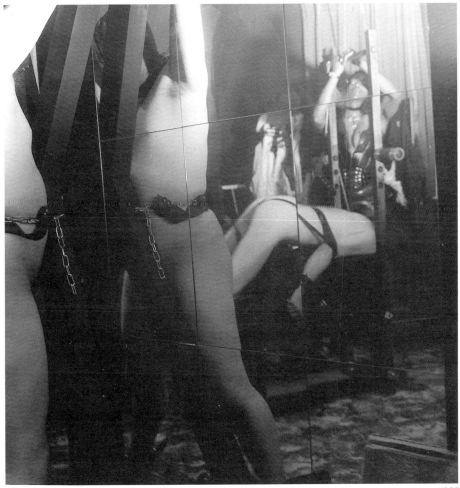

1995

In 1984, I became the first *Skin Two* official photographer. Professionally established and creating radical work that was exciting, exploratory and on the edge, my subsequent and eclectic experiences over the next few years have been liberating and a learning process.

In the first issues of the *Skin Two* magazine (put together by my colleague and publisher, Tim Woodward, and myself) I advertised my photographic services as "photographer of fantasies and fetishism." My studio was the basement dungeon below Tim's office, designer constructed by skilled craftspeople sympathetic to the scene. One of my first clients was a retired ex-Marine. Well-built, a fitness freak and macho in appearance, I was taken aback when he produced a suitcase carefully packed with satin negligees and pale pink underwear size 18. My initial anxiety evaporated into spontaneous laughter. He also showed me a roll of tough fibrous rope and explained that the professional dominatrices he visited were unable to bind him tightly enough for his discomfort. For the next hour he patiently taught me how to tie inescapable Marine knots, then he selected and gently unfolded a satin negligee from the flimsy tissue wrapping and changed into it. He needed to wear two pairs of skin-coloured tights to obscure his hairy masculine legs. Then, following his explicit instructions, I duly bound him up: this took an hour of hard work which I had not anticipated.. The eventual photography session was relatively quick as he was quite incapable of adopting many poses, but I suspect he enjoyed the preparation process more than I had anticipated.

Upstairs in his editorial office, Tim had installed a baby alarm linked to the dungeon in case any of my clients became unpredictably odd or demanding, and he observed that he could hear "tighter, more tight, pull the knots tighter" from time to time. He pondered on what sort of photography was taking place.

It was an amusing episode in retrospect but I learned that my photography skills were not always my clients' primary concern. This lesson taught me to adopt a more professional distance in future assignments. Some weeks later, my Marine collected his photographs; the only complaint he had was that the satin material of his negligee did not reveal sufficient rope stress marks. I am still puzzling over this observation.

Tim's dungeon-studio contained many 'toys' which served as props such as hooks and chains; a rack; a St.Andrew's cross, a tiny cell with a real prison door and plenty of leather harness, whips, canes and other adult toys. It was very appropriate for the kind of SM imagery that I was photographing with an exhibition in mind, and my subjects were all involved in the scene to different degrees. Some lived a totally obsessional SM lifestyle; others enjoyed infrequent visits to clubs, or dominatrices, or reversal gender roles. Most of my clients happen to be male cross-dressers. One sad gentleman told me in confidence, as he nervously unwrapped a precious pair of expensive nylon stockings, that he had saved up for seven years before daring to make a photography appointment with me. He was afraid his wife might discover his secret. He brought a selection of outsize women's garments and underwear

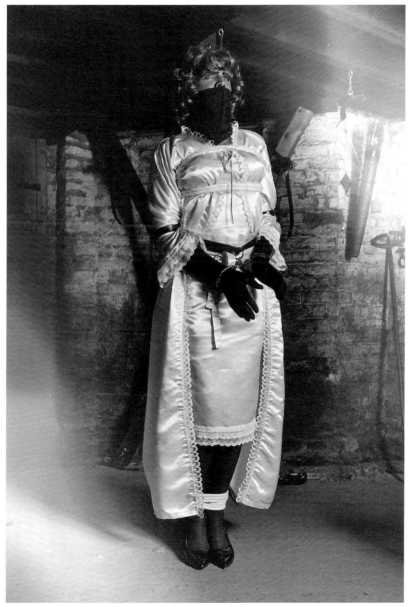

1986

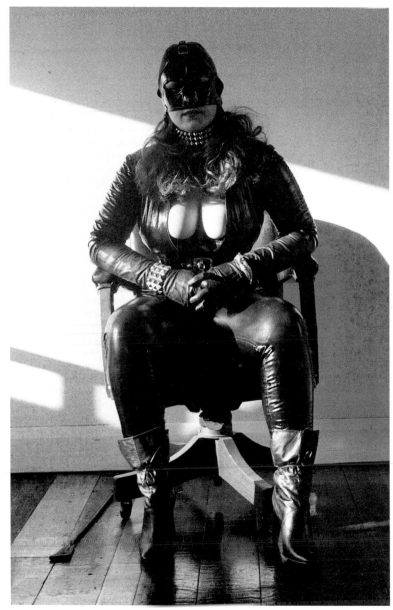

and was fastidiously obsessive about getting his stocking seams perfectly straight. During his photographic session he gained a little more self-confidence in his dress and make-up, and by encouraging him to assert his feminine identity in a safe space and with the subsequent images to assure him that his masquerade had been acknowledged, I felt that my role as a photographer was positive and rewarding. This gentleman eventually called me seven years later to discuss another shoot but in spite of my persuasion, this sadly did not materialize due to the weight of his guilt and fear of discovery. I await another seven-year interval.

The camera as catalyst is a phenomenon that I have become progressively more aware of, and acting in a cathartic role is another unexpected feature of my work. Although most of my clients clearly do not come to me as "patients", they feel sufficiently comfortable in my presence to reveal their fantasies as long as I respond to and acknowledge their masquerade. At times, I feel I have become the mirror for my cross-dressing clients, reflecting back their feminine beauty, even though I am actually looking at a rough, heavily-jowled and painfully shaven masculine face with pursed over-lipsticked mouth and layered foundation. But by engaging with their masquerade, I provide the necessary assurance that they crave. I have watched and helped my clients wriggle into tight, always too-tight, corsets and dresses, checked that their stocking seams are straight and their make-up smoothly applied. I have learned how they pushed and taped underneath their chests to create an illusion of deep cleavage, how they shade their shaven chins with thick pancake foundation, and where they can buy glamorous Joan Collins dresses and size 12 stiletto boots. There is a drawer full of different wigs and sexy over-sized underwear left behind by clients in my studio. I have helped them pose in stereotypically feminine postures that would horrify my feminist colleagues, and helped them select appropriate photos for specialized transvestite contact magazines.

Straight Seams 1987

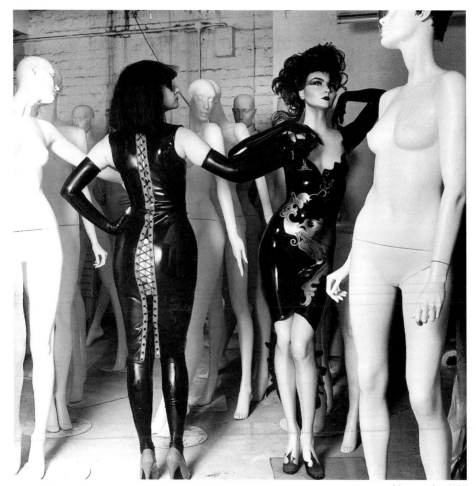

Mannequins 1986

Over the years I have made a series of colour portraits of these 'ladies' posing in their homes and these lavishly-presented images reveal a subversive subtext. It was Roland Barthes who influenced the way I take pictures:

"Photography is subversive, not when it frightens, repels or even stigmatizes, but when it is pensive, when it thinks." (Camera Lucida)

I used to meet many of my cross-dressing friends at a friendly social club in Bow called Tudor Lodge. Its clientele was East End gender-benders enjoying regular beauty competitions, trans-sexual striptease shows, and a sociable Saturday night out. It still is a venue where some husbands and wives go as two girls out on the town and is welcoming to all genders. Now countless meeting places, bars and clubs, even make-up salons, large-size dress shops and shoe shops have evolved into specialized spaces for cross-dressers.

Transvestism became mainstream and commercialized a few years ago, when Jean-Paul Gaultier appropriated the form for his catwalks and, simultaneously, mainstream photography exhibitions began to include a few images of TVs. Hollywood also saw a new character role and joined the bandwagon. Pop singers such as Boy George and comedians like Eddie Izzard had fully exploited the theme some time ago, but there is still now a stigma of guilt attached to the public social identity of transvestites. There are still many complex and sensitive issues about questions of homosexuality or bisexuality so that it is only in the entertainment and fashion industries where gender reversal is acceptable. Although most of my clients do not view their identity masquerade as a pathological or physical problem, a practical need for furtiveness remains and clients usually arrive at my studio in their everyday public masculine roles carrying two full suitcases of wrapped feminine identity. I believe that, as a female photographer, they feel less threatened by me than they would by a male photographer who might be judgmental or even mocking of their behaviour. There exists a feeling of comfortable conspiracy between us. I feel I have helped to lessen their guilt in a celebration of their duality.

Certainly my gender has helped me to gain entry into some of the private clubs and parties where they are normally suspicious of photographers, after repeatedly adverse tabloid coverage.

The intense curiosity that directed my work has evolved into a learning process and a desire to discover what drives these people, to where and how? And in this process, to additionally explore where my own boundaries lie, what is acceptable or offensive, and my limits of self-censorship. In terms of self-censorship, I have had occasion to turn down work which involved explicit sex for topshelf magazines. Not because I object

GRACE LAU

Photographer for
SKIN TWO Magazine

Your fantasies and
fetishes photographed
from £75

Name and phone number
to GRACE at SKIN TWO,
23 Grand Union Centre
Kensal Road
London W10 5AX

to explicit sex, or any form of consensual sexual activity, but mainly because I feel uneasy and voyeuristic when viewing a cheaply set up scene through my camera. My unease is reinforced by the abysmal quality of topshelf publications. Such objections may seem strange, particularly when I have had guys in my studio whom I have never met before, strapping their penis down to fit into women's panties and struggling to get into girdles and bras, asking for my help in hooking or tugging. But the self-censorship criteria is imposed when I no longer feel in control of the agenda. If I were asked to merely hold the camera to shoot a sexual act, I would feel as if it were just a crude and crass porn shoot which the participants could well set up to shoot themselves with a self-timer device. My creative engagement would be diminished and no longer essential. My role is not that of a mechanical recorder.

A few male (photography) clients have tried to involve me in their fantasy games. Here again, I would have felt a loss of personal control or, still worse, loss of photographic direction. So I have generally refused, although I have grave suspicions that some of them managed to manipulate a situation where I have to tie them up in so many different fashions that they have actually underpaid my services! I have often been asked whether my photo-sessions end in sexual activity because of the erotic fantasy element. I have to say that, really, the theatre and masquerade always end with total exhaustion, clients struggling to wriggle out of hot, sweaty, tight rubberwear, with me worrying about correct film exposures, and a return to normality is easily resumed. Sex? Perhaps later at home for them. The mental agility and their fantasy was sufficient: "it's all head-fucking." For them, mental orgasm is more pleasurable than the physical, or replaces the physical, and in the Aids Age, it is not surprising that such activities have become more widespread.

One element of the SM photography that I have found offensive has occurred when a submissive is abused by his maitresse over and above

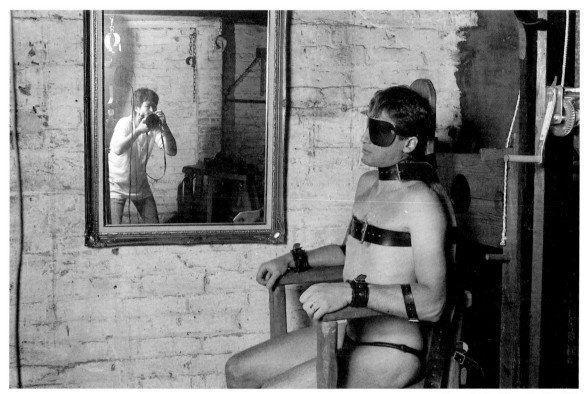

Through The Mirror Darkly 1988

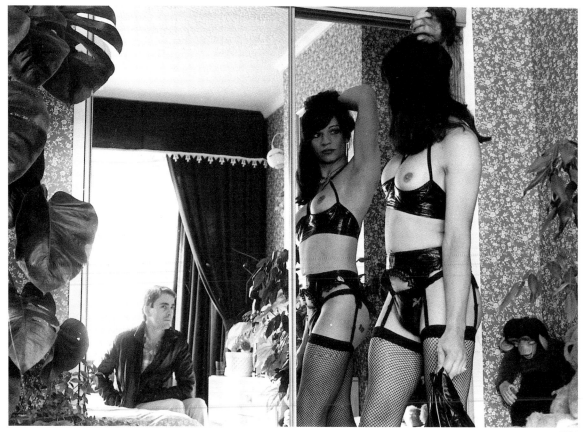

1986

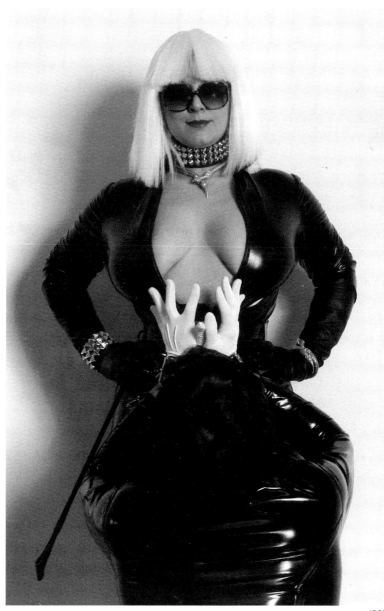

1987

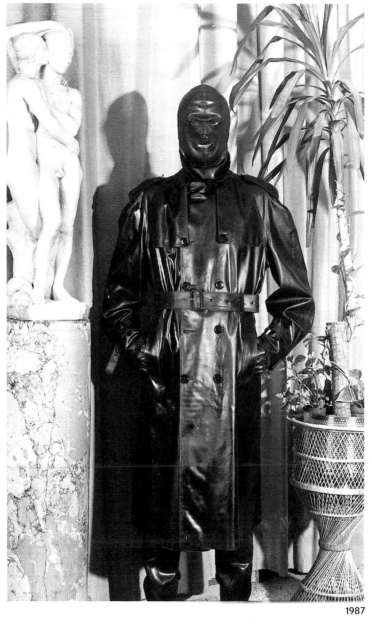

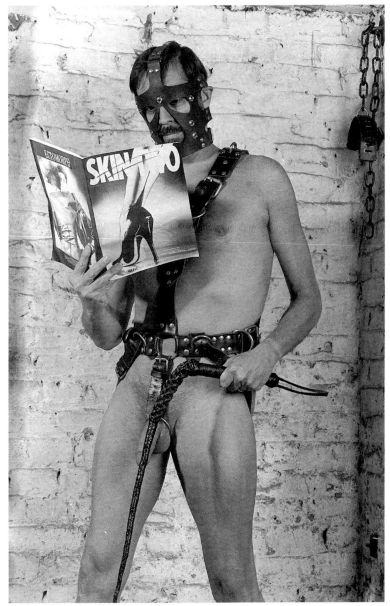

1986

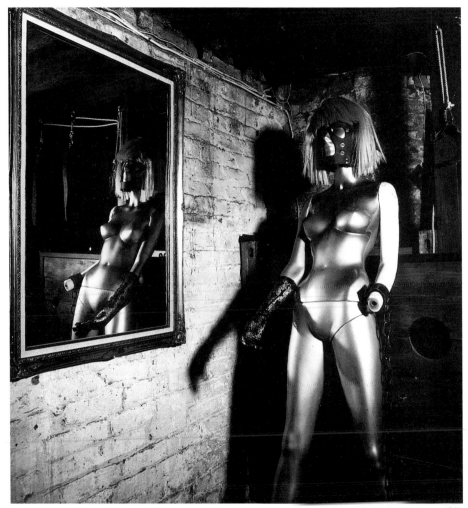

1987

his limit of endurance. There is always a codeword used between the sub/slave and dom for when the sub really can't take more pain, and many subs are obsessed with pushing their pain thresholds. In one instance, an over-excited dom got carried away with her power and continued to stick needles into her bound sub until he looked like a giant bleeding hedgehog, and I could not bear to watch. The play-acting bordered on the physical reality and I started to feel his pain, whereas he had probably transcended into a state of pleasure. I learned that the paradox of SM-play exists on shifting levels of pain and pleasure, power and submission, trust and fear. Clearly the client must have enjoyed himself because he returned a week later! The mental communication between the sub and dom during their play is necessarily highly tuned so that she can anticipate his desire. If he is gagged, there is no spoken dialogue, only her orders, but there is always a coded sign for him to indicate the end of their play. I say 'him ' for the sub and 'her' for the dom because that is the usual gender relationship. Occasionally there is a darker, more obsessive behaviour in the scene which verges on psychopathic abnormality, but generally speaking, the agenda is under strict control.

One of my most enjoyable commissions took place in Cornwall, at 'Westward Bound' a bed-breakfast-bondage hotel which offered a fully-equipped dungeon with

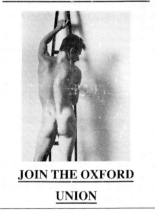
central heating and sound-proofing. A couple wanted me to document their tenth wedding anniversary celebrations at the hotel in the course of an evening and a night. They wanted pictures for a souvenir album. I brought along plenty of film, my zoom-lens, photo-flash kit and lots of energy.

We commenced work at nine in the evening with a bottle of champagne in their room to facilitate the elaborately prepared rituals. Her role was the master, in a Bertie Wooster suit. He changed into a French Maid uniform. I loaded my camera. We then trooped down into the ultra-luxury dungeon. They were enthralled with all the hardware equipment which included a roasting-spit, electric chair, iron cage, masses of chains, hooks, harnesses, saddles, crops, whips and stocks. Keeping a professional cool, I tried to manoeuvre my own lighting equipment around their activity which started to get seriously frenetic soon after we entered this bizarre Disneyland. They passed from one piece of equipment to the next with much giggling, much champagne, and energetic abandon. She bound him up in clingfilm to the spit and turned him around until he was so dizzy he could not stand upright, then we (I had to help her) suspended him upside down from the ceiling to increase his disorientation. I followed their exploits with my camera trying not to entangle my lighting leads with all the chains and ropes, and became

hot and exhausted by midnight while they were still planning more games. Ten rolls of film later, I had to retire to my bed. Their celebrations continued, I was told by the landlady, until breakfast time! My presence with a camera, I believe, was essential in helping to animate their games, and they ended up with a memorable photo-album.

Another episode that I will not forget for different, more sinister reasons, occurred in 1988. I met a good-looking gay Italian man whilst I was still searching for male nudes to photograph, and he agreed to pose for me with his boyfriend. I was exploring new directions in erotic imagery and this seemed appropriate. I took some trial pictures in his bedsit, both alone and with his boyfriend; not explicit, more evocative and affectionate. He was amiable and co-operative and the pictures were used for a few publications – including a membership recruiting poster for the Oxford Union showing his nude back view and the caption "Help Build A Great Student Body". A few months later, I was horrified to read that he had been charged with the murder of at least four gay men he picked up in London pubs during the few months I was photographing him. This sobering experience has made me more cautious about selecting my male subjects and to adopt a less frivolous attitude about the scene. On reflection, I do not believe that he would have harmed me, his victims were all gay men. But curiosity is an irrational force and drives me to take risks. The Oxford Union poster is on my wall as a reminder and a warning. He is in prison for life. I have personally not encountered any violence on the scene and, to my knowledge and experience, most of the people engaged in SM activities act out their theatrical fantasies in controlled and consensual circumstances where trust is crucial.

At Dunstable in Hertfordshire, there is an annual event, the Tattoo Convention. I have gone along with a tattooed and pierced friend who is a Financial Consultant, whose big thrill is to attend high-power financial meetings wearing pierced nipple rings and rubber stockings beneath his business suit. Then, at his Club in Pall Mall, he changes into his fetish

"Although it is difficult to ascertain the significance of irezumi, it is certainly one of the most exquisitely refined and skilful forms of sadomasochism that the mind of man ever devised".
Angela Carter *Nothing Sacred*

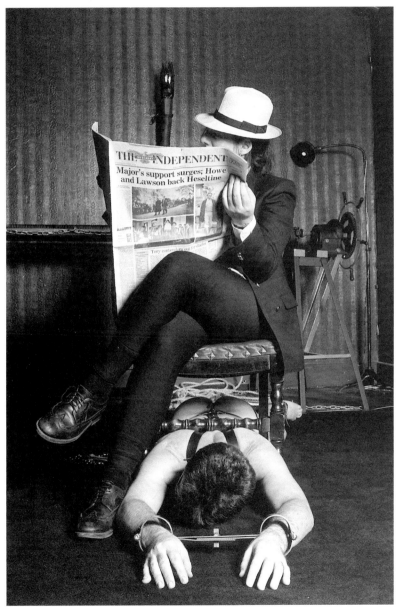

Bed Breakfast and Bondage Hotel 1991

wear for a night out. At Dunstable, he knew all the tattoo and piercing artists and practitioners, and consequently I was able to take photographs of many bizarre sights. To be tattooed can become an addiction from the first small pattern, and some people have their entire bodies covered. The Japanese school of tattoo art ('Irezumi') is serious enough for a museum to be set up in Japan where tattooed subjects can pre-sell their skin to be preserved for posterity, before they die.

The art of tattoo and piercing has recently become mainstream and fashionable, led by youth style and pop videos, but the real subversion is still practised by people such as my friend, the Financial Consultant, who deliberately takes social risks in balancing a game of duality. In his case, it is the risk that gives him the thrill, the danger of living on the edge between two polarized societies and even the danger of possibly being discovered by his conventional peer group.

This desire for an illicit thrill has been taken to the limit by another friend who did finally get exposed. He was Marketing Manager of a large company and was recently exposed by the tabloids for his relationship with a prominent dominatrix. I had taken a set of photographs of them both, in a spontaneous sub-dom scene, in my studio. Pursued by the media, eventually imprisoned for a month for fraud and contempt of court, he confessed to me: "I wouldn't have missed it all for anything; the prison was such a real experience!"

I often wonder how neighbourhood-watch teams can be so unobservant in certain suburban streets where spare bedrooms become miniature London Dungeons.

Is it the polite English attitude of 'it's not my business' that ensures dominatrices their safe privacy? However, a dominatrix who worked in Maida Vale was forcibly evicted by her landlords, the Church Commissioners, because of complaints from her neighbours about unspecified noisy activities. The Church Commissioners were not aware of her strict profession but she still was given 24-hours' notice to depart and had to enlist all her slaves to frantically dismantle her bulky disciplinary hardware all through the night, carrying the St.Andrew's cross, rack, and torture-toys down the tiny lift into a van and a new dungeon destination. She said if the bailiffs had managed to see her room, she would have offered them a free suspension on the St.Andrew's Cross as a bribe – or in revenge!

A very popular dominatrix in Muswell Hill is well noted for her strong caning techniques. She told me that her secret is her early morning work-out at the gym where she has developed her powerful biceps to the point when she can give fifty strokes of her cane without a pause, to the worthy – or unworthy – recipient. I have asked my banker friend, who is a keen recipient of CP (corporal punishment) about his obsession and his reply was: "It's so erotic to watch an attractive woman using her powerful body to give me pleasure. When she moves her whole body to swing the cane, it's so sexy I have to submit and bear the pain!" In his case, he prefers a mirror to be specifically placed in front of him to enable him to watch her action, as he is normally positioned over a bench. His latest news was that new skin had to be grafted on his bottom which had been

maltreated for twenty years and had, not surprisingly, become damaged. Such obsession would seem to be unhealthy, not just for the body, but he adopts a joking attitude and even shared a laugh with the hospital nurses.

Amongst the few women clients who came to my studio for private photography, one elegant and well-dressed woman asked for some sexy pictures of herself for her husband to remember her by, because she was stricken with a terminal illness and was progressively deteriorating in health and in her looks. It was a moving photo-session, all the more so because all three of us knew it would be the last one. She was already very thin and tired. She was pleased with the results, but I have not heard from her since. Although I had certain feminist reservations about making pictures of stereotypical and politically incorrect 'sexy poses', on this occasion I did not ask any questions or take a political stand. The lesson here is that politically correct attitudes can at times be dogmatic and negative, and that a flexible view can be no less honest or principled.

With each experience, I have learnt more about human nature, about bending rules sufficiently, about pushing boundaries in art and in myself. Also about stifling social conventions and, most of all, about the dynamic role and the responsibility of the photographer. It has been liberating, humbling, empowering and very pleasurable, too. The photographer's participation cannot be understated and the ultimate imagery that transpires is frequently an unscripted collaboration between real-life subjects and photographer. My camera does more than observe and document; my camera participates actively.

Consequently I believe that there can be no 'real-life' image. Every image taken by a camera is, to some degree, constructed for the camera. The camera never tells the truth, the camera is only capable of constructing stories.

'the act of photographing is more than passive observing. Like sexual voyeurism, it is a way of at least tacitly, often explicitly, encouraging whatever is going on to keep on happening'.
Susan Sontag *On Photography*

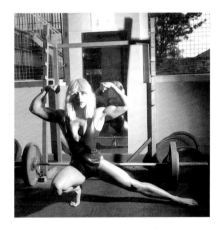

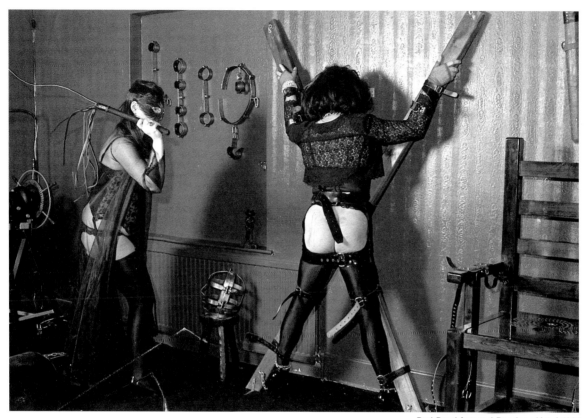

Bed Breakfast and Bondage Hotel 1991

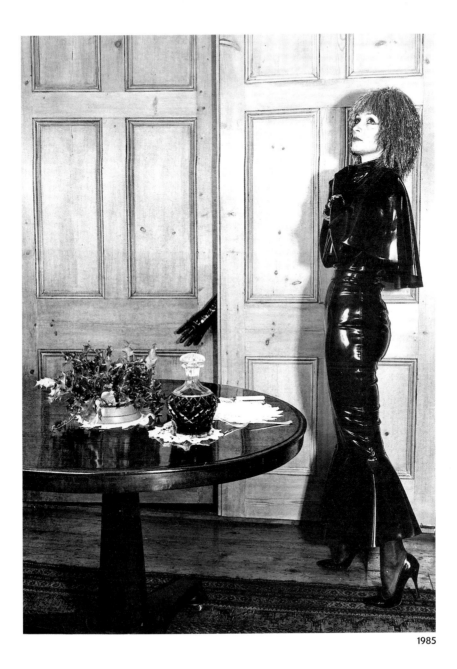

1985

67

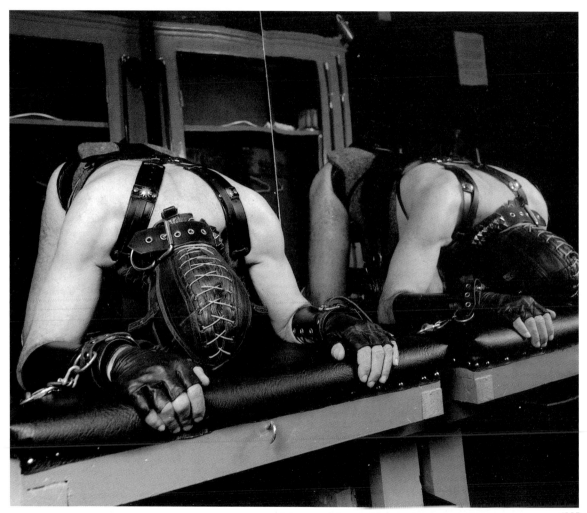

1985

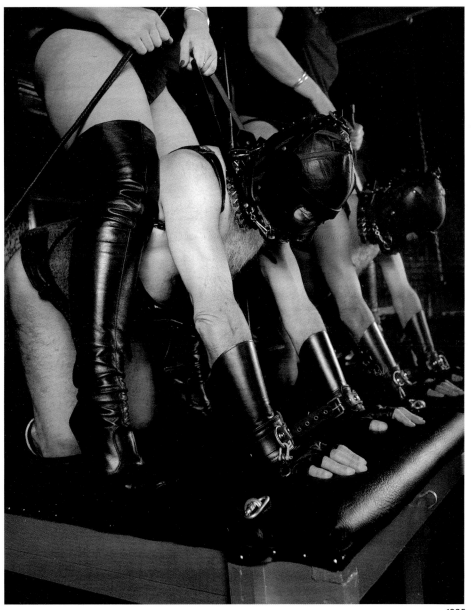

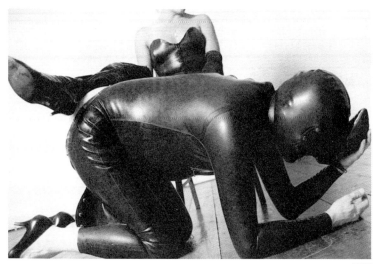

1995

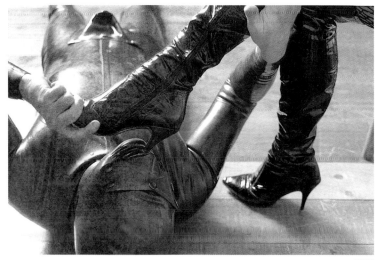

1995

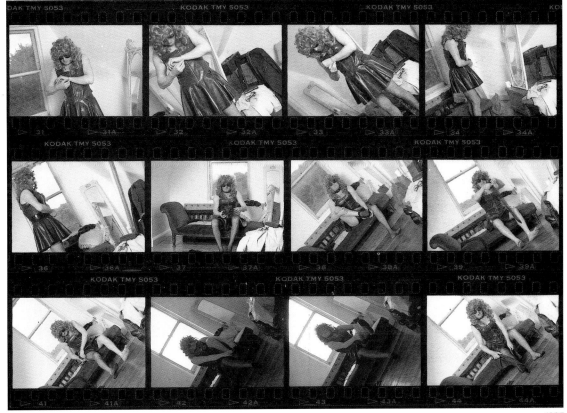

1995

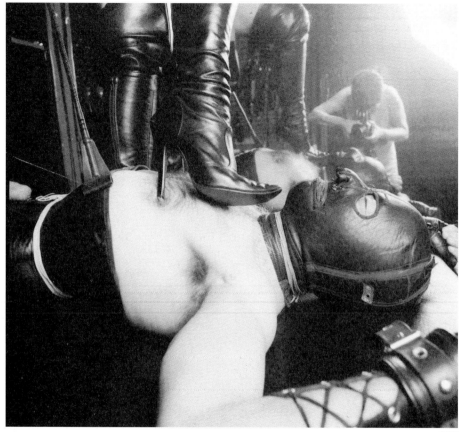

1989

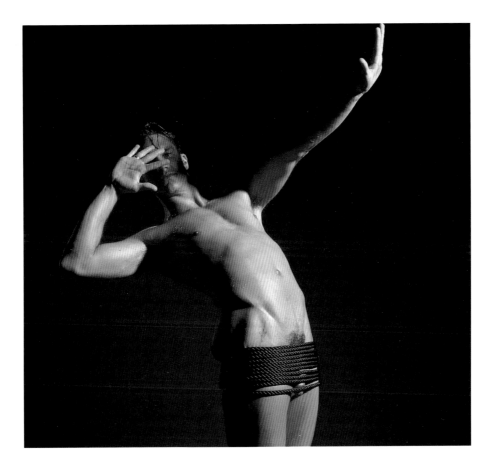

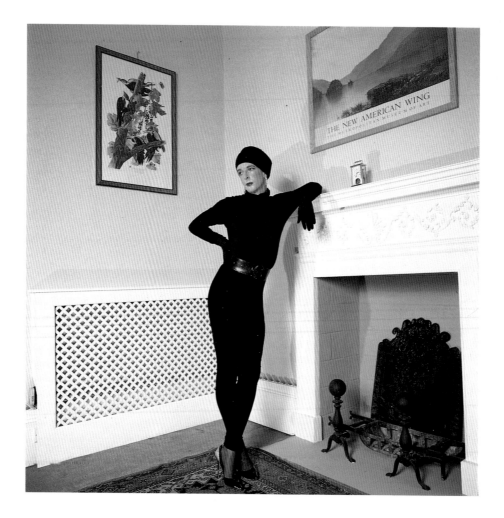

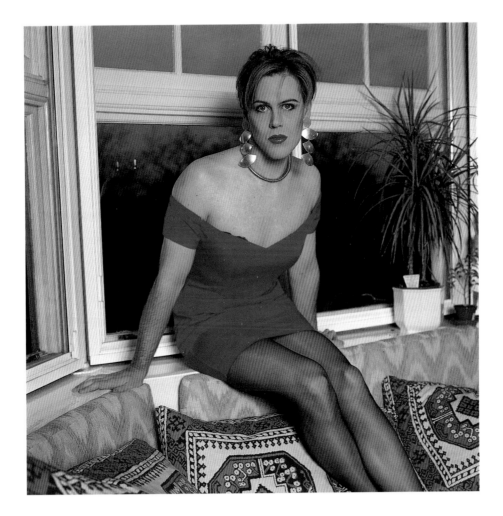

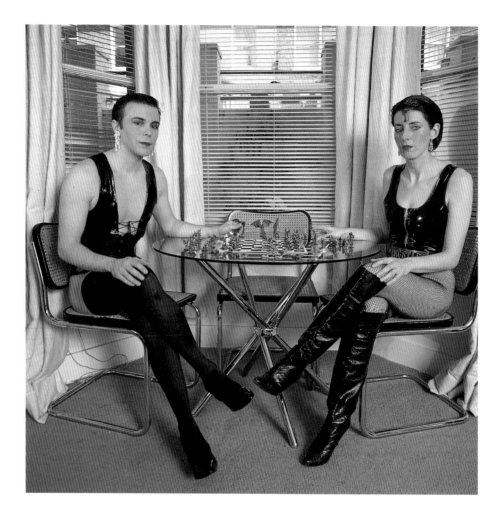

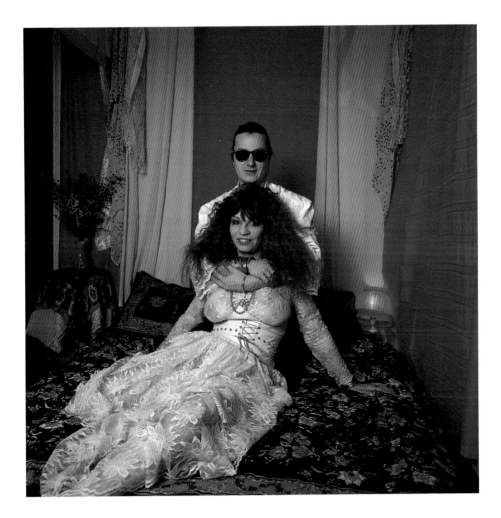

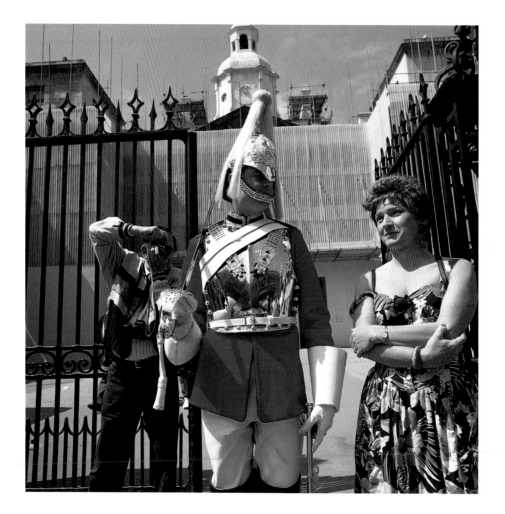

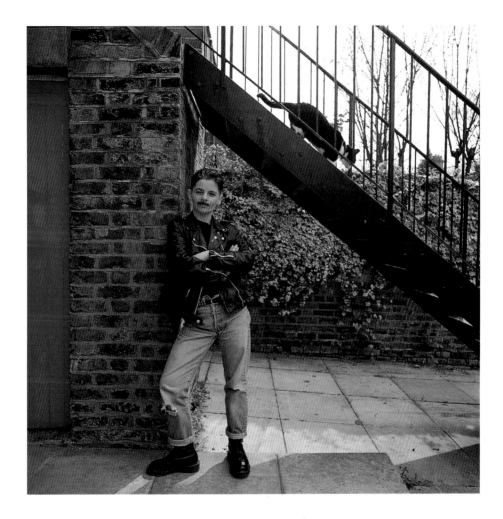

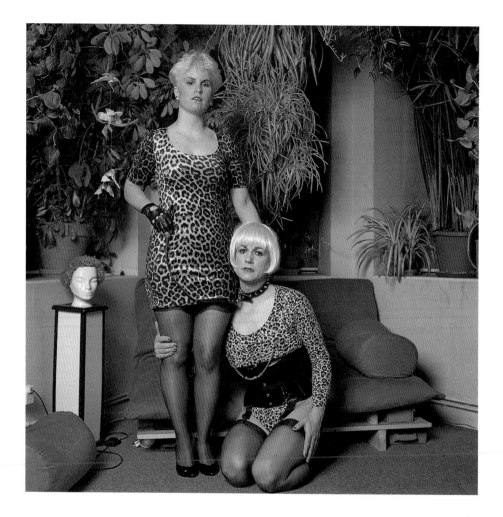

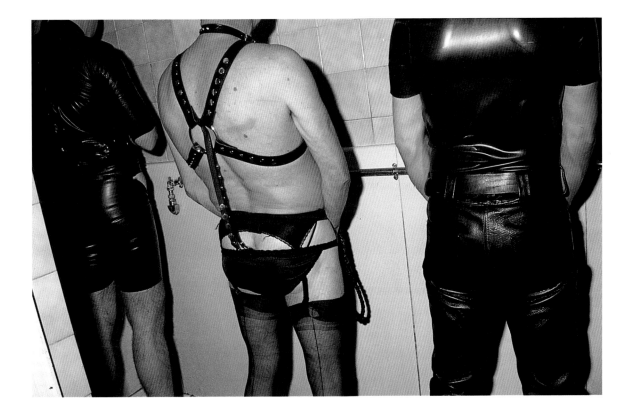

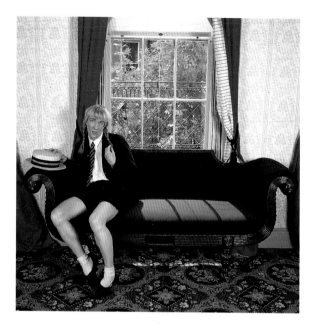 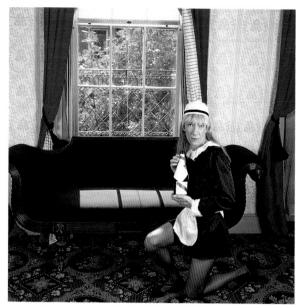

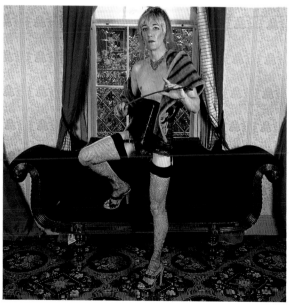 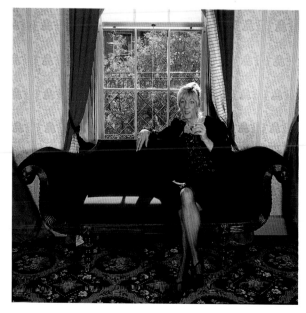

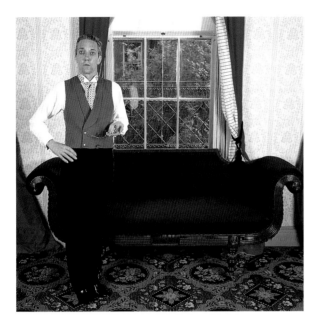

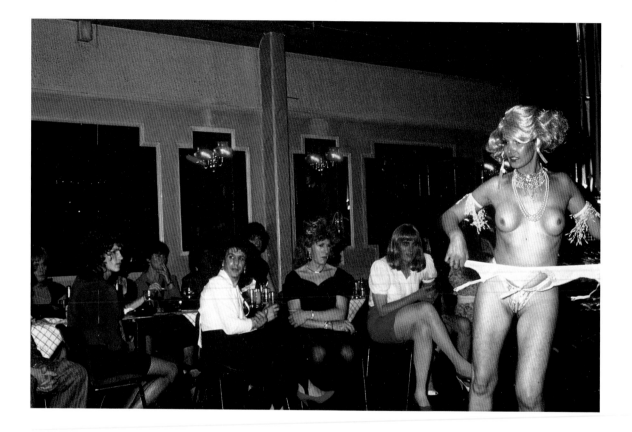

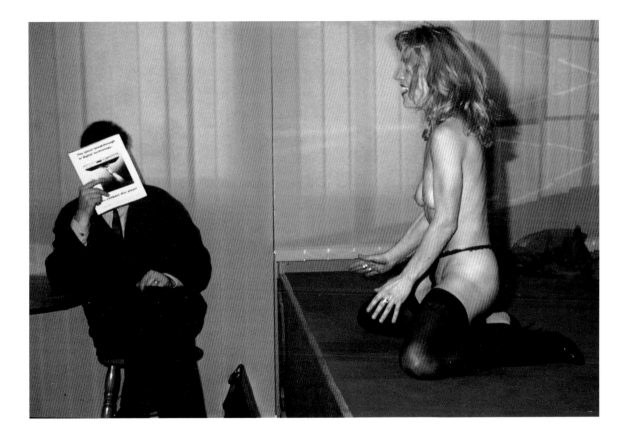

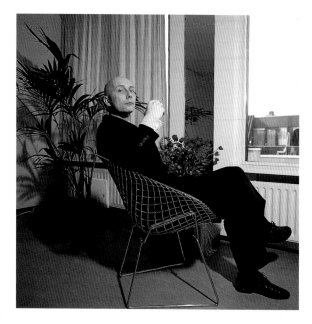
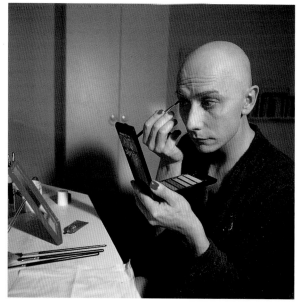
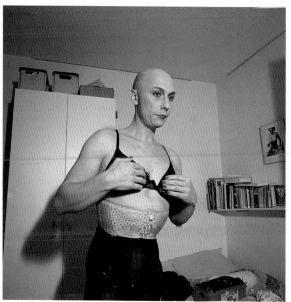
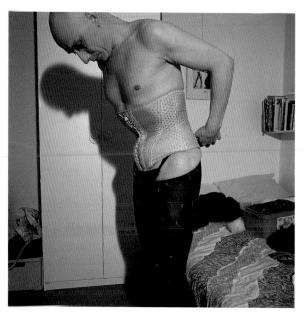

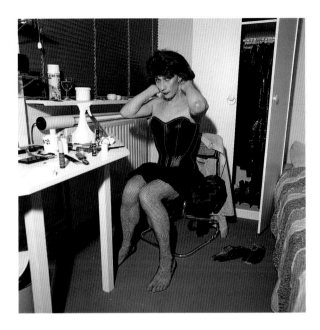

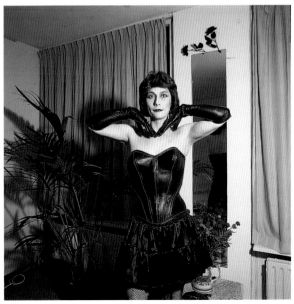

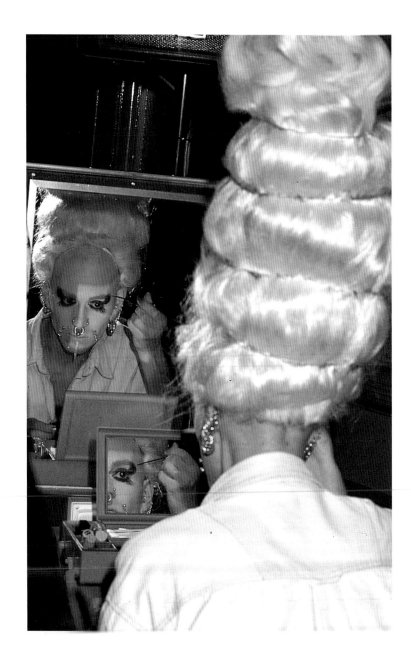

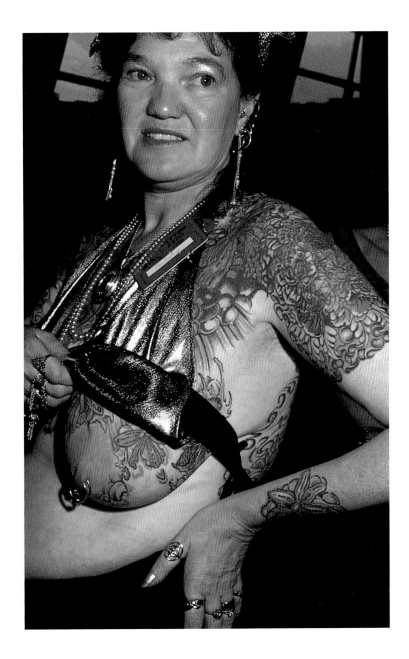

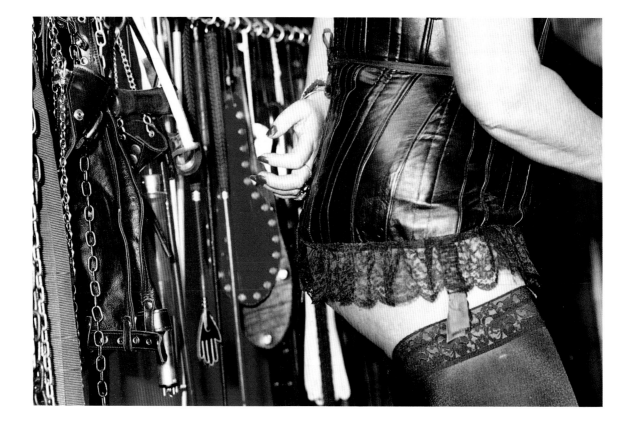

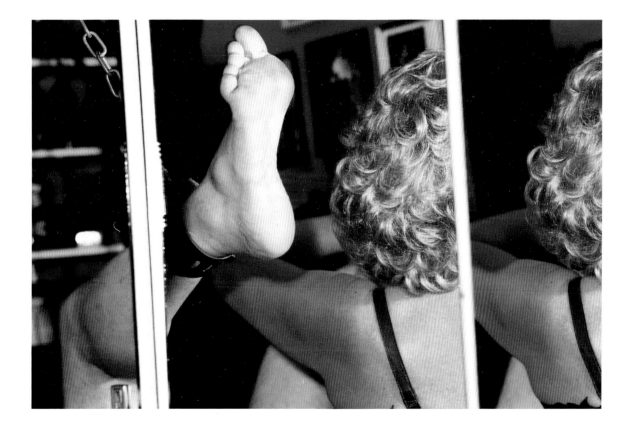

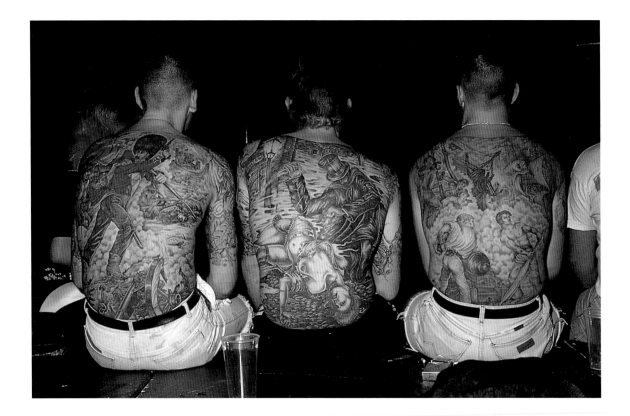

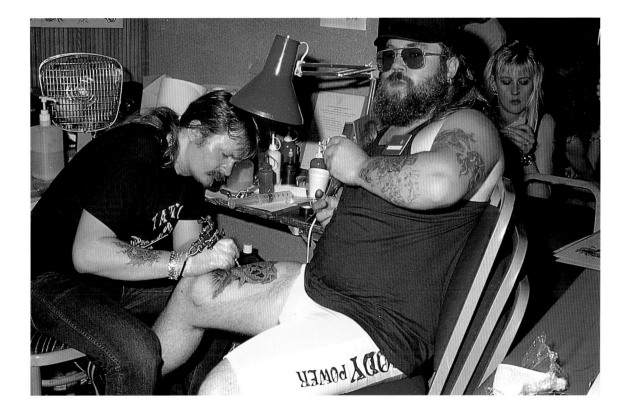

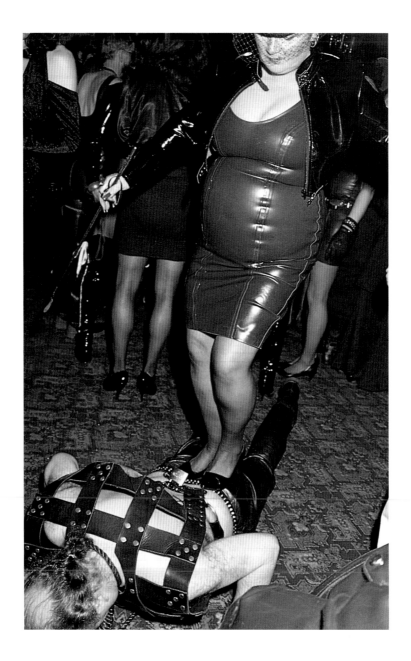

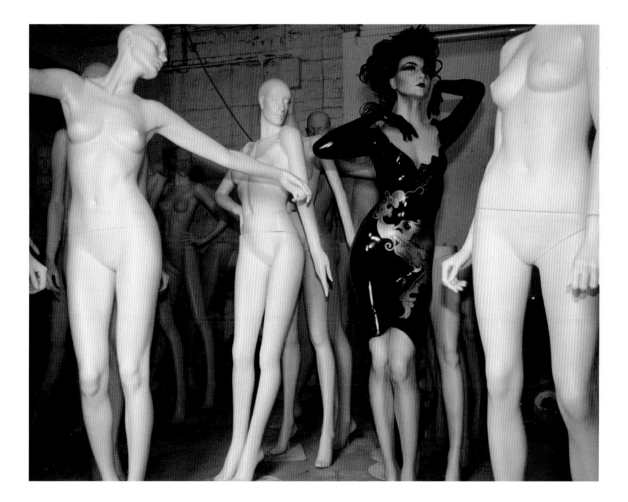

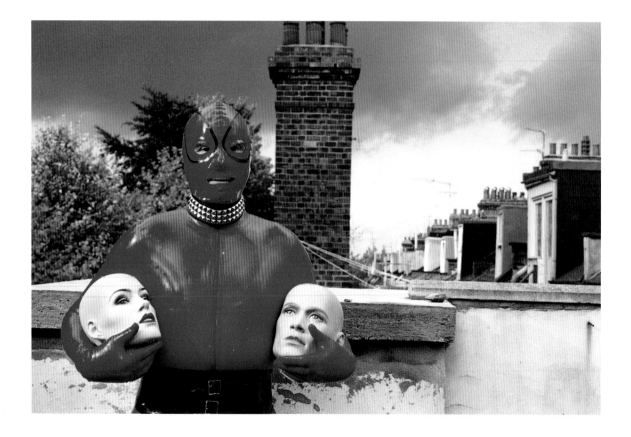

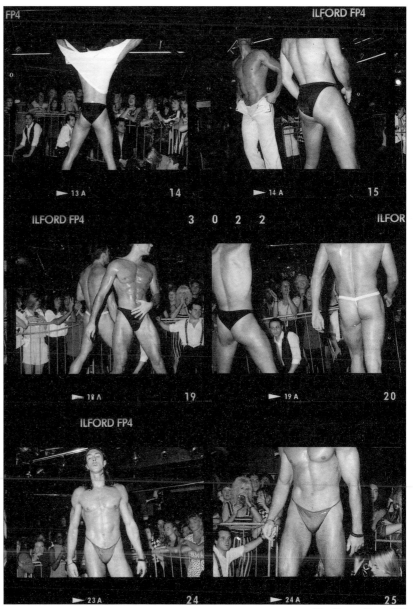

The Dream Boys 1993

Who's looking at whom?

"What is peculiar to modern societies is not that they consigned sex to a shadow existence but that they dedicated themselves to speaking of it ad infinitum, while exploiting it as the secret."

Michel Foucault *The History of Sexuality*

A new increase in discussions about sex, in both academia and the market place has helped to demystify this fraught area of anxiety. Yet, although the exposure has contributed to enlighten the general attitude, there is a parallel consequence that indicates some unease. For I have observed that it is the very nature of secrecy, the mystery and risks of clandestine activity, that give sex its specific aura of pleasure. So, by exposing all the shadows of desire out under the highlights, the essence of erotic pleasure can be significantly reduced.

For example, take striptease shows. Male strippers for women are now quite accessible in large cities and generally regarded as fun outings for hen parties, a "good laugh" and a respectable night out, generally with the husbands' approval.

Moreover, women commonly attend in party-groups, seldom by themselves, and there is much laughter, group bravado behaviour – with discreet disciplinary control by male bouncers and managers. The hunks are all physique and perform in roles conforming to icons of what men regard as female desire: sailors, cowboys and Indians, many in uniforms to imply power. Eroticism is not on the agenda. There is mass audience hysteria charged with loud humour, not sex, and the hunks seem to be performing for themselves. The collective faces of the women in the audience could be mirrors that reflect back the male physique to reassure the guys. They rarely engage in a sexual 'dialogue' with the women. There are also many, perhaps mainly, gay strippers and their G-strings are never ever fully removed. No penis is visible. With my camera, I am looking at a curious phenomenon: the women are looking at the men looking at themselves. But at least the women are now looking directly at the men, whereas previously they would only permit themselves a sideways glance. The easy accessibility of this show removes any clandestine element, and simultaneously, reduces any sexual tension – the very essence of eroticism.

At a lunchtime stripshow in a city pub, the scene is very different. The female strippers are raunchy, offering themselves completely naked, sexually and yet in control of their act. They appear to enjoy themselves. The exclusively male audience do not express their pleasure as vocally as the female audience at the male strippers'

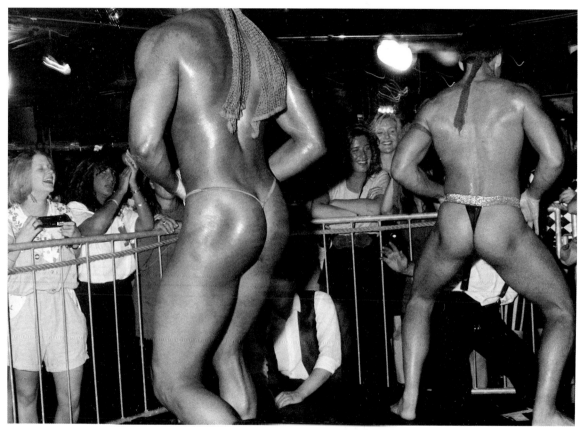

1993

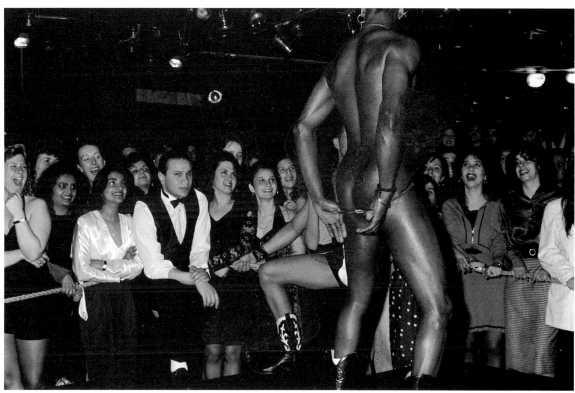

Who's Looking at Whom? 1993

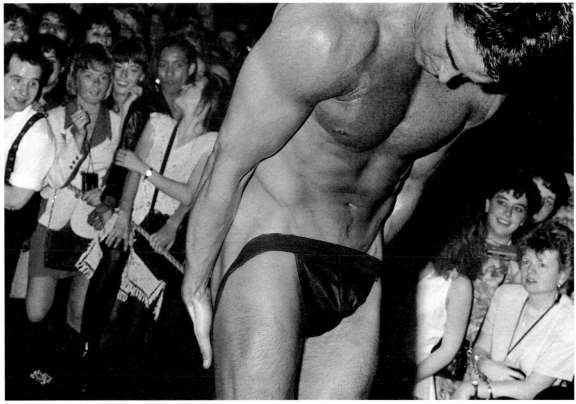

1993

show, and their heavy silence is potent with erotic desire.

The men also generally attend alone and sit or stand at the bar, by themselves. They are uneasy at seeing my camera and hide behind their copies of the *Financial Times* whereas women audiences at the Dream Boys show are relaxed and many bring along their instamatics.

The illicit atmosphere of the city pub, even at noontime, is permeated with the frisson of clandestine sexual tension absent during the male strippers' show, and I feel prohibitive about taking photographs because of objections from the men. They have probably told their secretaries that they are at a business meeting. Here the interactive look between the female strippers and the male audience is a sexy dialogue, and the distance between them provides a space into which the male spectator can project his fantasies of possession and pleasure. There is no room for my intrusive camera, I am clearly not part of the act. But I have observed, and I am curious about the relative lack of real erotic performances for women: would they want men to perform sexually, or do women prefer private pleasures in the intimacy of their homes with their partners?

I have visited commercial 'live' sex-shows with performing couples but the arena is generally uncomfortably sited in a sleazy and cheap set-up, and the mechanical action is void of any eroticism. I fail to see how any woman could be aroused, and even a buzz of voyeurism cannot be injected into this vacuous space. Perhaps the predominantly male spectators are able to fantasize beyond their immediate environment and do

not feel so uncomfortable in these sex theatres. Perhaps the very sleaziness enhances the clandestine factor and thereby raises the pleasure level. Is sex surrounded by so much guilt that it only becomes pleasurable in the darkness of illicit mystery?

My documentary photography work moved from stripshows in the early 1990s to another area of perverse curiosity: the 'Readers' Wives'. This particular activity is confined to topshelf men's magazines where male readers submit personal photos of their wives in sexy poses. They may get a vicarious thrill by imagining that their wives are being desired by other male readers. Most of the wives are average women, some more or less plain, of various sizes, ages and shapes. I was able to document some sessions in a professional studio run by the magazine conglomerate where a professional make-up artist and a professional (male) photographer attended to the wives (and very occasionally, husband).

Readers' wives are often professionally photographed in studios and not at home, contrary to common expectation. In one particular session, I was allowed to shoot from behind the professional photographer, out of frame and out of the way, which was just as well because I felt uncomfortable and somewhat embarrassed by what emerged.

The wife concerned was middle-aged and, to my eyes, somewhat subdued. The husband was assertive, directive and proud. It was his show; he directed his obedient wife and also the professional studio photographer. I remained in the shadows behind. It was a 'tomato ketchup' scene and she had to be photographed in a

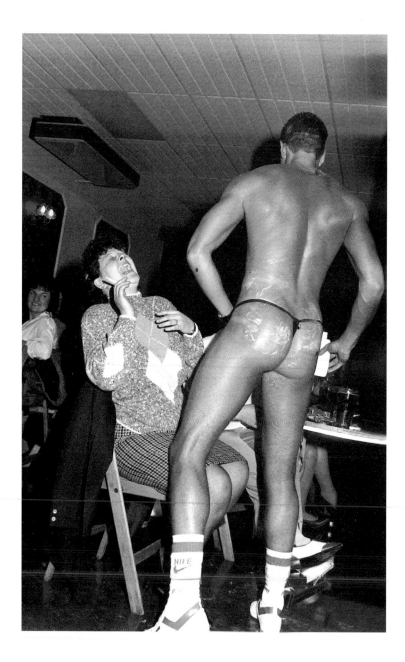

bathtub full of the red ketchup, in her underwear. My question to the readers of 'Readers' Wives' is: What is the attraction of that? I was genuinely puzzled.

What interested me in this scenario was the power-play between the actors, the respective roles of the studio photographer and myself as observer-photographer, and the inter-related dynamic relationship which also involved the subsequent 'readers' or spectators of the images. All the players in this game came from different perspectives, with different objectives, and the resultant picture would be paid for and read by an anonymous audience as a frivolous item in a marginal magazine. Somehow, I felt that the issue of photography as a means of positive communication was being misappropriated here. What was being said? I could not understand the language in this case, which caused the discomfort I felt. Additionally, as I was reduced to being an inconspicuous presence I felt like a voyeur watching secret sex-play, and the lack of control further increased my unease. Another problem was that as a woman I could identify with the wife's unease, or what I thought was her unease. Perhaps she was not really reticent, merely a bit shy? Although my work is about carrying critical theory into documentary practice, this was a testing case in the learning process.

All the while I was documenting strippers, male and female and trans-sexual, the participants were there by consensual choice. Also, I was able to make pictures in their full view, apart from a few male spectators at the city pub. The 'Readers' Wives' work conflicted with this approach and my role felt diminished. My questions remain unresolved about this particular scene.

My work has essentially involved a process of exploration, and this process increasingly became more significant than the end-product, that is the photographic print. It was the process of developing an engagement with my subjects during the making of the image that animated me. The subsequent picture itself was important as documentary evidence and in terms of aesthetic value, sometimes merited a place on the wall for contemplation and pleasure. And, of course I am concerned that an audience should also be moved by my images. Primarily, however, the focus of my work has become centred on the dynamics of developing an image, or images, and the documentary narrative of the image. The cultural context around my subject provided a backdrop for my stories.

Towards this end, in 1992 I set up Exposures with a few women photographer colleagues and with the objective of promoting women's visual perspectives based on women's own experience and history. The first 'Women Photograph Men' workshop was created by Robin Shaw amid much media interest as the first photographic workshop for women to explore photographing male nudes.

Following its success it seemed appropriate to run a simultaneous workshop for men – but with a different emphasis: 'Men Re-View Women' which challenged the conventional glamour photography formula and presented a studio situation in which the male photographers worked in close collaboration with the female subject via dialogue and mutual experimentation.

"What women have to adapt to as their 'femininity' (particularly in the process of growing up) is itself the product of representations. Representations therefore cannot be simply tested against the real, as this real is itself constituted through the agency of representations."

Victor Burgin Thinking Photography

"What about the pleasures of image-making and looking? Scopophilia – that is, the sexually motivated pleasure taken in looking – is not the sole preserve of men: women photographers can and have affirmed their sexual pleasure in taking sexualized images of men's bodies. Neither is sado-masochistic violence and there are many ways in which images may be constructed and enjoyed by women viewers that are both subtle and explicit suggestions of the powerful sexual fantasies which many women experience."

Lola Young Mapping Male Bodies

Our 'models' were aware of the inherently sensitive issues involved in nude and erotic photography, and thus in control of their participation.

We have developed a safe and creative space for the workshops to run successfully for many years, and are currently exploring the group dynamics of a mixed gender workshop 'Double Take'. It is interesting to note that, following media exposure on our women's workshop, we were besieged by telephone calls from potential male models wanting to undress in front of women photographers, and one caller even offered his credentials as having: 'an extraordinary organ'! We still receive more calls from these eager strippers than we have from women photographers, and I suspect there is scope to start a workshop where male strippers could be auditioned by a group of women photographers...

The subsequent images from the workshops are interesting, but the success of the workshops relies primarily on the experience of working together with nude subjects in an equal relationship. Establishing open communication is especially difficult in the men's workshop as men's cultural conditioning to take control needs to be subsumed in order to achieve co-operation from Mary, our assertive and confident 'model', who is uninhibited about being naked but demands the right to object or contribute her view during the photo-sessions.

The women's workshop works on a different level as they have to learn to take control, to gaze at and to communicate with a nude male 'model' and to confidently direct the photo-shoot, in terms of technical camerawork as well as creativity. I have observed that certain men in their workshop diverted the discomfort they felt around Mary by intensely focussing their attention on the lighting equipment, or on the selection of films and lens, rather than make eyeball contact with Mary. The male's active gaze can waver when confronted with an unstereotypical female. My co-tutor for the men's workshop is Mick Cooper, a psychology lecturer and counsellor, who is able to talk with the men about their attitudes and relationships to women and pornography, whilst I engage

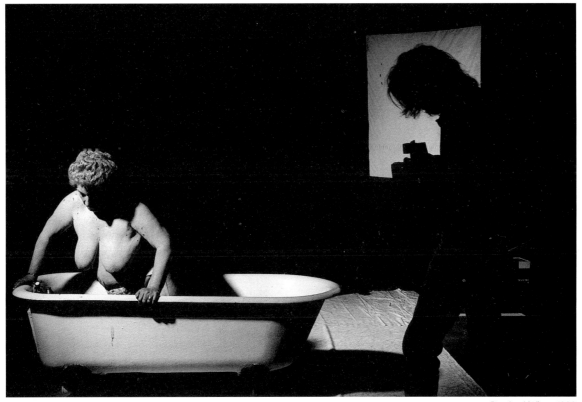

Readers' Wives 1992

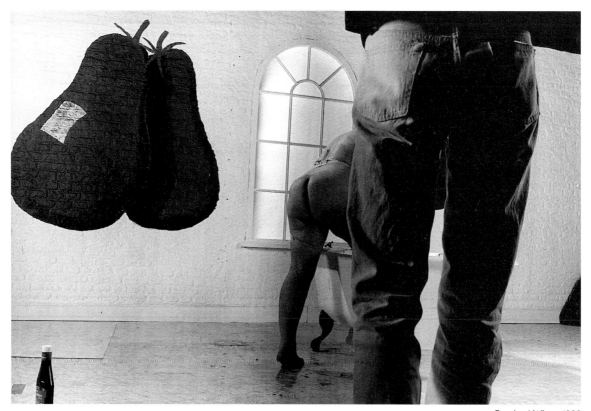

Readers' Wives 1992

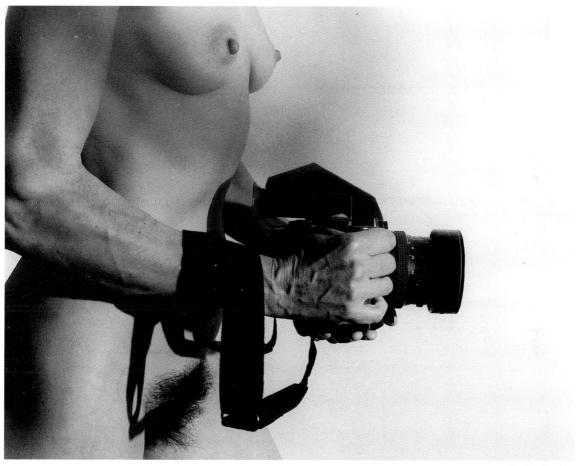

Paul Aylin 1995

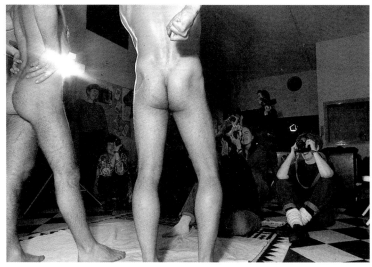

Women Photograph Men workshop 1993

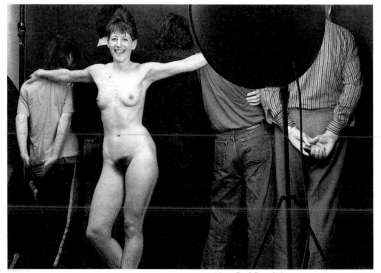

Men Re-View Women workshop 1994

with their technical and creative aspirations. This may appear to be a therapy workshop rather than a photography one and there is certainly an element of therapeutic expression in terms of questions about guilt, about sex, and about relationships, communication and identity. The visual language alone obviously cannot resolve all these questions, but using photography in the environment of our workshops allows the issues to be raised and explored with a view to reducing their negative and dysfunctional facets. This is a particularly rewarding consequence of our photography workshops, which have been positive lessons for all involved – for the men and women participants, for the 'models' and for us, the tutors. It is still an ongoing process and the visual dynamics involved are constantly challenging our perceptions.

Much has now been written about the formerly exclusive male gaze and about how women are gazing back and reclaiming or redefining their sexual identity. The balance of gender power has shifted to a considerable degree since I first started searching in the shadows for male nudes to photograph. The human body has become the site for intensive discourse, media scrutiny and commercial exploitation. In the area of photography, it has become a genre generating considerable focus from students to anthropologists, cultural essayists and other social scientists. It is now perfectly acceptable in mainstream advertising and mainstream women's magazines to appreciate the male nude (albeit preferably the rear view), whereas the female nude has become problemized and subject to political correctness.

Furthermore, the *Skin Two* fetish scene has become so fashionable and mainstream in the '90s that an annual international Rubber Ball takes place at the Hammersmith Palais in central London, a concept unthinkable ten years ago.

The formerly discreet tattoo and body-piercing practitioners are now in popular demand in youth culture and rubberwear is on sale in the high streets. SM iconography is appropriated by advertisers and film/television

"In a world ordered by sexual imbalance, pleasure in looking has been split between active/male and passive/female. The determining male gaze projects its fantasy onto the female figure, which is styled accordingly."
Laura Mulvey Visual and Other Pleasures

"Out of a new self-confidence, some women have turned to look freshly at their own bodies, and at men's....what is exciting is the richness, the variety and the fantasy of the new women's art – its willingness to take risks, to open doors, slowly perhaps to develop new ways of seeing and feeling."
Margaret Walters The Nude Male

"Postmodernist art accepts the world as an endless hall of mirrors, as a place where all we are is images, … and where all we know are images…. there is no place in the postmodern world for a belief in the authenticity of experience, in the sanctity of the individual artist's vision, in genius or originality. What postmodernist art finally tells us is that things have been used up, that we are at the end of the line, that we are prisoners of what we see."

Andy Grundberg *Crisis of the Real*

producers are competing to show 'tasteful' SM imagery to an insatiable audience.

In the '80s, I felt that I was really pushing boundaries, both artistic and personal. These shifting boundaries have now reached a metaphorical cliff-edge. Curiosity is still a driving force to look over the edge and perhaps discover a new mirror to go through. But there is a feeling of existing on the cutting edge for so long that I need to back-track some distance in order to pause and contemplate, before exploring the void ahead.

The journey through the looking-glass has been a kaleidoscope of experiences which would have remained invisible without my curiosity and my camera. And the lessons learnt about reflections, representations and masquerade beyond the visible mirror-glass have been profoundly enriching.

Before looking for further areas to explore, the past lessons need to be consolidated by setting them down here in text and images, or the whole story would appear to be a distant fantasy in an imagined Wonderland.

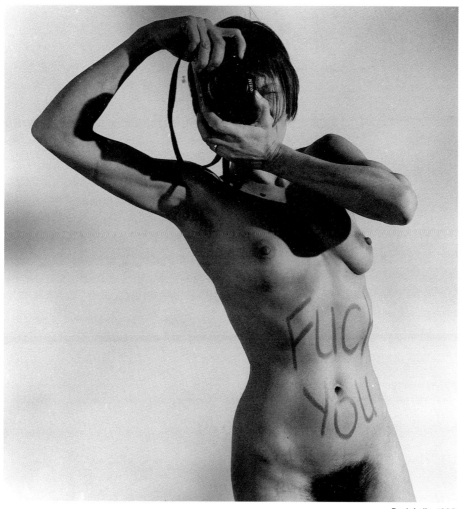

Paul Aylin 1995

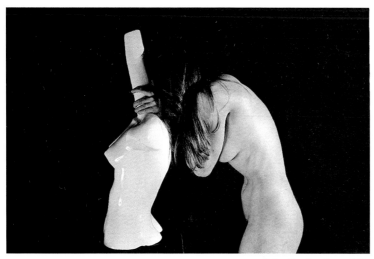

John Comino-Jones 1993

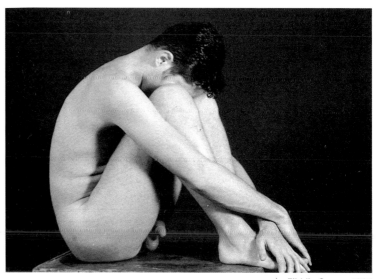

Eibhlin Savage 1995

114

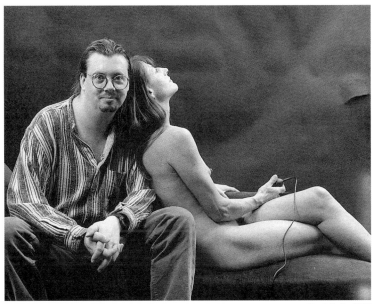

Paul Aylin 1995

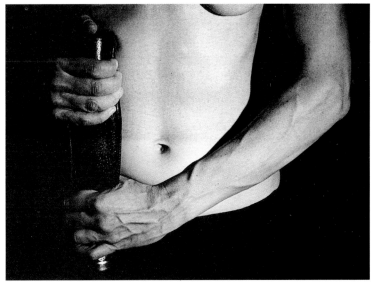

Jon Tarrant 1995

115

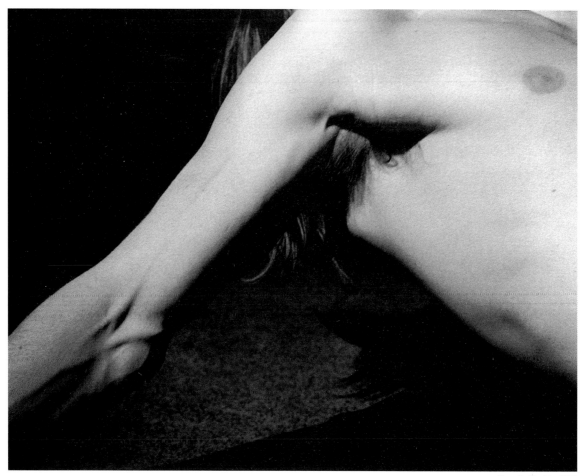

Dundy Smith 1995

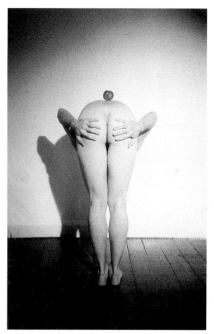

Rachel Hanks 1994

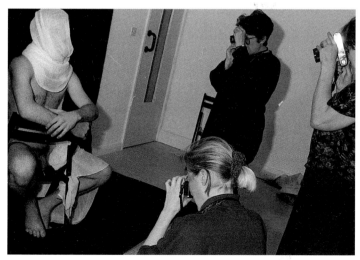

1993

117

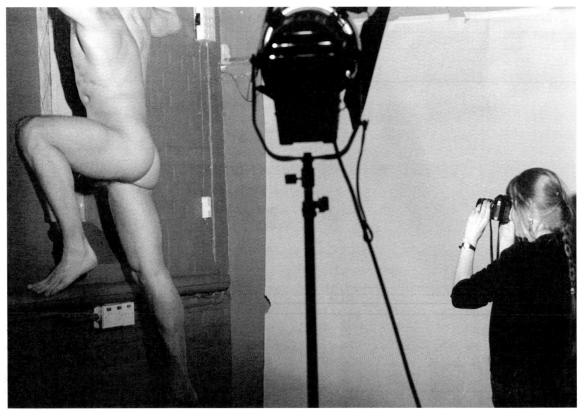

1996

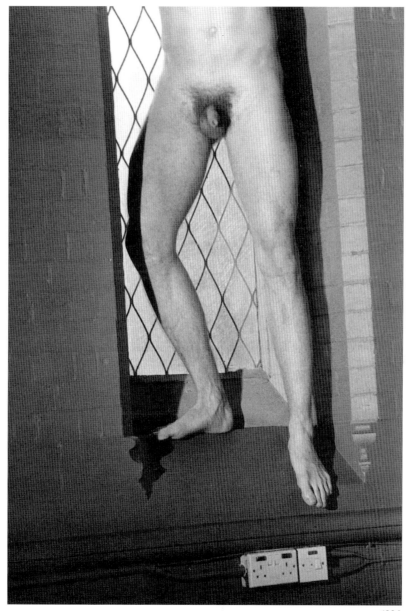

1996

119

Bibliography

Introduction

1. John Berger, *Ways of Seeing*, BBC Publishing/Penguin Books, London 1972, p.8.

2. Ed. Naomi Salaman, *What She Wants*, Verso, London, 1994.

3. *Touch Papers,* Alison & Busby, London 1982, Masochism 2. Quoted with permission of the author.

4. Lewis Carroll, *Through the Looking-Glass* (last poem spelling Alice Pleasance Liddell.) Puffin, London, 1994

Chapter One

Michèle Roberts, *Women's Studies International Quarterly*, London, 1979.

Roland Barthes, *Camera Lucida*, Hill & Wang, New York, 1981.

Tony Ray-Jones, *A Day Off: An English Journey*, Thames & Hudson, London, 1974.

Andy Grundberg, *Crisis of the Real*, Aperture, New York, 1990.

Linda Williams, Introduction in *What She Wants*, Verso, London, 1994.

Lewis Carroll, *Through the Looking-Glass*, Puffin, London, 1994.

Chapter Two

Jean Baudrillard, *Simulations*, Semiotexte, New York, 1993

Roland Barthes, *Camera Lucida*, Hill & Wang, New York, 1981.

Sigmund Freud, *On Sexuality*, Penguin, London, 1977.

Angela Carter, *Nothing Sacred*, Virago, London, 1982.

Susan Sontag, *On Photography*, Penguin, London, 1980.

Chapter Three

Michel Foucault, *The History of Sexuality*, Vintage Books, New York, 1980.

Victor Burgin, *Thinking Photography*, Macmillan, London, 1982.

Lola Young, 'Mapping Male Bodies' in *What She Wants*, Verso, London, 1994.

Laura Mulvey, *Visual and Other Pleasures*, Macmillan, London, 1989.

Margaret Walters, *The Male Nude*, Penguin, London, 1978.

Andy Grundberg, *Crisis of the Real*, Aperture, New York, 1990.